Amphoto Guide to
Special Effects

Lida Moser

AMPHOTO
American Photographic Book Publishing
An Imprint of Watson-Guptill Publications/New York

I dedicate this book to my dear family—R., S., H., G., R., J., A., and C.—and to the reader.

Copyright© 1980 by Lida Moser.

First published 1974 under the title *Fun in Photography* by Amphoto, American Photographic Book Publishing Co., Inc., Garden City, New York.

Revised 1980 in New York by Amphoto, American Photographic Book Publishing, an imprint of Watson-Guptill Publications, a division of Billboard Publications Inc., 1515 Broadway, New York, N.Y. 10036.

Library of Congress Cataloging in Publication Data
Moser, Lida.
 Amphoto guide to special effects.

 (Amphoto guide to series)
 Edition of 1974 published under title: Fun in photography.
 Includes index.
 1. Photography—Special effects. I. Title.
II. Title: Guide to special effects.
TR148.M67 1980 778.8 80-23194
ISBN 0-8174-3523-9
ISBN 0-8174-3524-7 (pbk.)

Manufactured in U.S.A.
First printing 1980.

Amphoto Guide to
Special Effects

OTHER BOOKS IN THE AMPHOTO GUIDE SERIES

Available now

To be published

Contents

Introduction

What do you do with a camera? For most people, it is enough of a challenge to point the camera at what's in front, press the button, and get a good picture.

However, this book is for people who want to go further, who want to experiment, who want to be able to take a camera and color film and create images that are unique and original, and their very own. These people want to find out how to bend the rules, how to extend the limitations and boundaries of the film and the camera and mold what is in front of the lens as a sculptor molds clay. They want to create pictures where the elements of mood and emotion are emphasized.

This book will explain how to put together in one picture things that are far apart in time and space; how to add or change color; how to capture the sense of movement; how to create an image that will delight, intrigue, and startle.

Some people will call this "trick photography," but it is more than that. I think it is being a magician or, better yet, an artist.

Some of the techniques and methods I've developed, which will be fully described and explained in this book, were used to make the following pictures:

- A 25-cent aluminum funnel, turned into a flying saucer over the skyline of Manhattan.
- A girl, photographed in the studio, seen running from a dark and mysterious old Victorian house, at night.
- A beautiful face in a field of flowers.
- A spirit emerging from a brick wall.
- The face of a man, and the woman who was thinking of him.
- A painting on an artist's head.
- A man's head, stretched and duplicated.
- A leaping dancer, flying.
- A city on the side of a girl's face.
- A man meeting himself on the beach.
- An American Indian in the desert sky.
- Crossbeamed lights coming out of a man's eyes.
- Two people—who never left the studio—in the jungle.
- The horizon of the Sahara desert across a girl's eyes.
- Ghostly skeletons around a skull.
- A galaxy in a dark sky (created with shiny metal auto accessories, wire, and aluminum foil).
- A person floating below the surface of the sea.
- An eye coming through the clouds of the sky.
- A tin toy, turned into a man living in a fiery world.
- Wild abstracts made from pieces of colored foil.
- One profile turned into six, in three different colors.
- A crystal ball, turned into a colorful planet floating in space.
- The sea, the sky, and the clouds on a man's face.
- A ballerina in the center of a man's eye.
- A person, wrapped in plastic, turned into two dancing ghosts.

These effects were achieved primarily by double exposing, and also by sandwiching two or three slides, using optical devices and filters, varying the focusing and the

time exposures, using black-and-white photographs and adding color to them, using projected color transparencies, and, last but not least, utilizing many different types of reflective surfaces.

The most adaptable type of camera for this kind of work is a 35 mm single-lens reflex. However, once you have mastered the various techniques they can be applied to almost any kind of camera. All the techniques and methods that will be described can be applied by you; and once you are finished shooting and the film is out of the camera, you need only process the film in the ordinary way. Nothing further needs to be done.

Let us hope that you will find your way, as I have, into an exciting area of photography, one that will give you a great deal of pleasure and allow you to express yourself

It has often been said in many ways by many people that creative work is a form of play. This work, I assure you, is creative; so let's proceed and have fun.

1

Double Exposures

Before you enter the creative world of double exposure, there is one ability that must become second nature to you. You must learn to look at a color transparency and see, not what is pictured, but the light areas, the middle-toned areas, and the dark areas. You must learn to think of film as a blotter that soaks up light. Where the light doesn't hit it, the film remains unused.

The area of Fig. 1-1 shown in Fig. 1-2A, the highlighted side of the girl's face, has completely used up the film and will come through and dominate anything you double-expose on it; your second exposure will register on the film only in the areas shown in Figs. 1-2B and 1-2C. In other words, the light area, which is actually a very small portion of the film, is all that has been completely used, the middle-toned area has been partially used, and the dark areas have not been used at all. The latter two areas can absorb other images and colors. Figs. 1-3A and 1-3B are two other possible types of pictures.

I cannot stress enough the importance of developing the ability to analyze color transparencies in terms of tonal values.

PREPARING TO DOUBLE-EXPOSE

There are two basic ways to double-expose. You can double-expose frame by frame as you go along; most cameras have a device to allow you to do this. Or, you may shoot off a set of pictures on a whole roll of film, and then

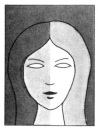

Fig. 1-1

Fig. 1-2A

Fig. 1-2B

Fig. 1-2C

Fig. 1-1 is a simplified illustration of a girl's head lighted from the side, against a black background. Figs. 1-2A to C show the three main areas of Fig. 1-1 in terms of highlights (A), middle tones (B), and dark tones (C.)

when you are finished, put the roll of film through the camera again, right away, in a day, or even in a month. Personally, I prefer this second method; it allows more flexibility. You can take many different types of pictures without having to worry about double-exposing right away. If you use this method, keep notes and records of the first exposures, so that you will have a guide when you make the second exposures on top of the first exposures. Say you have photographed someone in close-up, medium, and full shot, as in the illustrations below; for the second exposures there are several things you can do. You can double-expose with the same or other persons; you can use abstract color designs; or you can use country scenes, flowers, trees, city scenes, traffic, crowds, or objects. These are some of the possibilities. The next chapter will have very specific instructions for your first roll of film, to start you off; subsequently you can try to do whatever you want.

Preparing the Film

When you put a fresh roll of film into the camera and you plan to double-expose with it, you must prepare it in the following way, in order to keep the film leader from going back into the cassette when you rewind it after the

Figs. 1-3A and B. In a photograph like the example on the left, the second exposure will register on the dark area of the body. In the example on the right, only the highlighted figure will come through; the second exposure will come through in the dark areas around the body.

first exposure, or the first-image layer of take I (as I will be referring to it): You must fold the film back from the end of the leader with two ⅛" creases (Fig. 1-5).

When loading the film onto the take-up spool, fold back these two creases and push them into the slit. Upon rewinding the film, the creases catch inside the slit of the take-up spool and act as a stop. When you remove the back of the camera, you will see that the film leader is outside the cassette. Another way I have of keeping the film leader from disappearing into the cassette is to rewind slowly and hold the camera near my ear. I can hear when the cut-away

Fig. 1-4. One series of possible first exposures, as seen through the viewfinder. Frames 1 to 6 are close-up shots of the model, frames 7 to 13 are medium shots, and frames 14 to 20 are long shots.

portion of the film comes off the top sprocket wheel. I stop at this point to make sure that the film is still attached to the take-up spool, or the end of the film is at least outside the cassette.

Let us go back to the point when you load the camera for the first exposure. You have made your two creases at the end of the film leader, you insert them into the slit of the take-up spool. You move the film forward one or two frames to make sure that it has caught properly. At this point, you take a ball-point pen and draw a line on the film along the edge of the opening of the cassette (Fig. 1-6)

With the back still off the camera, press the release button and move the film forward one more frame, and again, with a ball-point pen, draw a line on the film along the edge of the cassette opening (Fig. 1-7). Count the sprocket holes between the two lines. If there aren't eight sprocket holes, you must repeat the process; by the third time, the film should be moving forward a full frame at a time, a full frame containing eight sprocket holes along each edge.

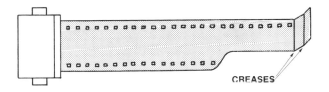

Fig. 1-5 (Above). Crease the end of the leader.

Fig. 1-6 (Below). Draw the first line.

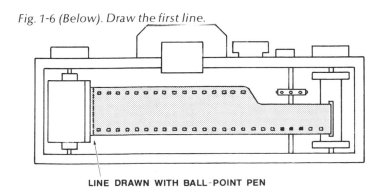

LINE DRAWN WITH BALL-POINT PEN

15

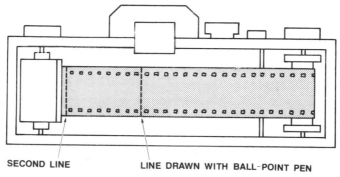

SECOND LINE **LINE DRAWN WITH BALL-POINT PEN**

Fig. 1-7 (Above). Draw the second line.

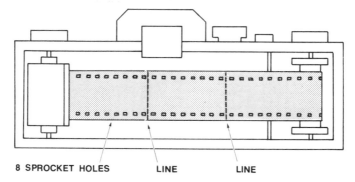

8 SPROCKET HOLES **LINE** **LINE**

Fig. 1-8 (Above). Make sure there are eight sprocket holes between the second line and the edge of the cassette.

You now have two lines drawn on the film; press the release button one more time and move the film forward one more frame with the back still off the camera. You should have two lines drawn on the film and eight sprocket holes between the second line and the edge of the cassette (Fig. 1-8).

Only now do you close the back of the camera; you are ready to start shooting. When you have finished the whole roll of film, rewind the film carefully, as described above. The creases have acted as a brake, and you can open the back of the camera. Ideally, the film should be as it is in Fig. 1-6, with the leader still attached to the take-up spool. If you plan to put the roll through again immediately for your second take, do not remove the film from the

camera, or the leader from the take-up spool. Press the release button and move the film forward, first one frame, then one more. Almost always you will find that the ballpoint-pen marks are lined up properly, as in Fig. 1-8. I have personally put a roll through four times, one time right after the other, and, using this method, have always had the film line up correctly.

This marking of the film is very important in doing the work presented in this book; a marked film will be referred to from now on as a "prepared" roll. Of course, you could start your own procedure and purposely not have the frames lined up. I know people who have done this, and they have gotten some very interesting compositions. In Chapter 10 you will find a description of a series of pictures photographed this way.

Let us assume that you have finished the first shooting on a "prepared" roll of film and removed it from the camera with the leader outside the cassette opening. Some time has elapsed, and you are ready to put it back into the camera for your double exposures. Don't be alarmed if it takes several tries before the pen marks line up. The first time I made my planned double exposures, it took a half-hour to get the film lined up properly, but I finally did succeed. Be patient and keep at it. The marks will line up eventually. It's usually a case of changing the length of the leader, or making another crease or two.

2

Making Double Exposures

This book is intended for people in all stages of photography, from experienced professional photographers to people who are perhaps one step beyond just having started taking pictures. Such people have been in photography long enough to have gained a certain ease with the camera and know the basic rudiments: how to use a light meter, how to adjust the aperture and time settings, and how to load film. This doesn't mean that this is simple or easy work. It can get quite complicated, and it entails hard work and logical thinking, but I truly believe that even if you have recently started taking pictures you can succeed, if you have the courage and the desire to try out new ideas and to follow explanations and instructions carefully.

If you feel you understand the concepts in Chapter 1, you should now get ready to take pictures. Perhaps you might read the text more than once, until the relationships between the light areas and the dark areas, and the functions they serve, are clear to you.

My feeling is that if you do the work as we go along in this book, we can think of the work as a discourse between two people working together at the same thing, as an exchange and a friendly sharing of day-to-day experiences. The actual doing will clarify the explanations, and when your first completed roll of film is returned to you from the color-processing laboratory you will have the added thrill of seeing results, and your understanding of

what you have read will be reinforced and, I assure you, clarified.

We are going to stop here to define certain words and phrases that will be used frequently throughout the book.

Many of the types of photographs described and explained in this book are commonly called *double, triple, or even quadruple exposures*. However, when I'm giving a step-by-step explanation of a specific shooting problem the words *exposing* or *exposures* will be used only in reference to the exposure-meter readings, and to the aperture and time settings. Only in general discussion will I call a slide or transparency a double exposure, a triple exposure, or a quadruple exposure.

In the specific explanations, the first shooting on a roll of film will be referred to as the *first take*, not the first exposure, although in reality it can be called that. When the roll of film is put through the camera a second time, it will be called the *second take*. Each succeeding time the same roll of film goes through the camera, it will be referred to as the *third take, the fourth take*, or as *take I, take II*, or *take III*, and so on.

Instead of saying, "You now make your first exposure," I will say, "You now take the picture," or "You now press the button." When a fresh roll of film is put into the camera for the first time, the language used will be, "You now get ready for your first take," or "You now do take I" or "You now make take I." I repeat, the terms *double exposure, triple exposure*, and the like will be used only when a general reference is made to a picture.

Since this book deals almost exclusively with color photography, the terms "slide," "transparency," "picture," "photograph," and "shot" will be used interchangeably to refer to the same thing, that is, a slide of transparent color film, usually a 35 mm color slide. There will be a few times when 2¼″ × 2¼″ or 4″ × 5″ transparent color film will be used, but these formats will always be designated by size. A black-and-white photograph will always be referred to as a black-and-white photograph or a b & w photograph.

Throughout the book, I will refer to your "studio." Your studio can be anything from a fully equipped professional establishment to a corner of a room where you control the background and the lighting.

FIRST DOUBLE-EXPOSURE SHOOTING

Just to get you started I'll list the things you will need for the first shooting:

1. Model, preferably a patient and loving friend.
2. 35 mm camera with a normal lens.
3. Roll of Ektacthrome film (160 Tungsten), 35 mm, 20 exposures.
4. Tripod.
5. Exposure meter.
6. Lighting equipment (at least one 250-watt 3200 K bulb in a 10″ or 12″ reflector).
7. Masking tape.
8. Optional: "barndoors" to control the spread of light on your reflector floodlight, or two strips of black paper about 12.7 × 35.6 cm 5″ × 14″) to be taped to one side or both sides of the reflector. Although it's not usually done, I often push in the sides of the reflectors (Fig. 2-1). These oval reflectors are very handy, and help shape the spread of your light.
9. Colored gelatins for your lights, or several rolls of cellophane in different colors (red, blue, green, orange, violet, yellow, pink), generally found in gift-wrapping shops. You can tape the sheets of cellophane to cardboard frames, which you hang on the reflectors.
10. Black background paper or cloth.
11. Slide sorter and slide viewer.
12. Slide projector.

Loading the film is extremely important; you should do it carefully and with precision. Keep the book open to the appropriate pages and meticulously follow the instructions and explanations given with Figs. 1-5 through 1-8.

With the camera loaded and ready for shooting, you can now begin work with the model. The model should be wearing a dark garment. Have your model sitting on a backless chair at least 76 cm (2½ feet) in front of a black (or very dark) background. Place the light to the model's left.

At this point you should be concentrating on lighting, composition, and exposure. The rapport between the model and the photographer, and the model's facial expression, are not important. That is why the model should be a patient and loving friend who is sympathetic and will

Fig. 2-1. Left, the reflector sides in the normal posi-
tion; right, the sides of the reflector pushed in to help
focus the light.

not distract you from technical matters. Later on, after you
have done several rolls of film using these techniques, you
can work on expression.

Look through the viewfinder of the camera and
move forward or back until your composition resembles
Fig. 2-2. There should be no light on the background, and
there should be very little light on the shadow side of the
model's face. If necessary, put baffles on the reflectors.
Barndoors attach to the reflector and help control the light,
or you can make baffles out of oblong pieces of black paper
and attach them to one or both sides of the reflector with
masking tape.

Now you take the light readings: first, on the back-
ground; second, on the shadow side of the model's face;
and finally, on the highlighted side of the face. This last
reading is the important reading The reading on the
shadow side of the model's face should be at least three
stops lower than the left-side reading, and the background
should register nothing. If this isn't the case, adjust your
light. You can make the background darker by bringing
your model forward away from it.

Let us assume that your reading on the highlighted
area of the face is $f/4$ at 1/30 sec. (A different reading is
possible, of course.) After you get the light reading, and be-
fore you start to shoot, make an exposure chart. Next to
each frame number write the exposure setting that you
will shoot at; and when you are shooting, follow the chart
precisely.

21

The exposures you shoot at should be charted, so that you will have a thorough understanding of how the results were achieved. At this stage there should be no mysteries or surprises. There will be plenty later on.

In multiple shooting, a wide range of exposure bracketing is used. Right now you should bracket from 1½ or 2 stops under the reading through 1½ or 2 stops over the reading and all the half-stops in between. Later on, when you see how the bracketing works, you needn't use such a wide range.

EXPOSURE CHART

(Take I light reading, f/4 at 1/30 sec.)

Frame #	Take I		Take II
1	f/4	1/30 sec.	
2	f/4–5.6	"	
3	f/5.6	"	
4	f/5.6–8	"	
5	f/8	"	
6	f/8	"	
7	f/5.6–8	"	
8	f/5.6	"	
9	f/4.–5.6	"	
10	f/4	"	
11	f/4	"	
12	f/2.8–4	"	
13	f/2.8	"	
14	f/2–2.8	"	
15	f/2	"	
16	f/2-2.8	"	
17	f/2.8	"	
18	f/2.8–4	"	
19	f/4	"	
20	f/4	"	

On the second take, make sure you get as many combinations of exposures as possible. I vary only the apertures, but you may also want to vary the time settings. But again, let that come later on, when you feel you understand the effects of the variations. The fact remains that the second take feeds extra life and exposure into the underexposed areas of the first take, and this is what you

Fig. 2-2. Take I.

have to get the feel of. This feeling can only come through the experience of shooting, seeing your results, and checking back to the chart.

Only after the chart is made do you shoot. Shoot strictly according to your notations on the chart. If you feel that it will be helpful, use a tripod.

As soon as you have completed shooting the 20 frames of take I, rewind the film as described earlier. When you can feel you've come to the crease at the beginning of the roll, double-check by removing the back of the camera and seeing that the pen lines are lined up correctly against the opening in the cassette as you advance the film one or two frames.

Close the back of the camera and you are ready for take II. Just move the light to the other side, the model's right. Place it so that as little light as possible spills onto the shadow side of the face. To add a little interest, move the camera back about a foot and tilt it slightly downward, so that the model's head is higher in the frame. If you wish, you can also tape a gelatin or cellophane *scrim* (light-diffusing panel) over the reflector floodlight. Study the effect of the colored scrim on the model's face. If you use cellophane, you may need more than one layer to have the face affected by the color. There are many other things you might do: move the camera closer to get a larger image, or use another person. For now, let us stay with these simple variations.

You are ready to take your light readings for take II. Do them exactly as you did the readings for take I: first on the background, then on the shadow side of the model's face, then on the highlighted side. The readings should be similar to the ones for take I. The colored scrim may reduce the light reading somewhat, depending on the depth of the color, but you can bring the light reading up by moving the light closer to the model (Fig. 2-3).

Before shooting take II, you must go back to chart and fill in the aperture openings for take II. If you study this chart you will see that there are very few repetitions of aperture combinations. I also suggest that you throw frames No. 3, 6, 10, 17, and 19 slightly out of focus for take II. It will give you another variation to study when you see the results.

EXPOSURE CHART

(Take I light reading, f/4 at 1/30 sec.)
(Take II light reading, f/4 at 1/30 sec.)

Frame #	Take I		Take II	
1	f/4	1/30 sec.	f/4	1/30 sec.
2	f/4–5.6	"	f/4	"
3	f/5.6	"	f/4	"
4	f/5.6–8	"	f/2.8–4	"
5	f/8	"	f/2.8	"
6	f/8	"	f/2–2.8	"
7	f/5.6–8	"	f/2	"
8	f/5.6	"	f/2–2.8	"
9	f/4–5.6	"	f/2.8	"
10	f/4	"	f/2.8–4	"
11	f/4	"	f/4–5.6	"
12	f/2.8–4	"	f/5.6	"
13	f/2.8	"	f/5.6–8	"
14	f/2–2.8	"	f/8	"
15	f/2	"	f/8	"
16	f/2–2.8	"	f/5.6–8	"
17	f/2.8	"	f/5.6	"
18	f/2.8–4	"	f/4–5.6	"
19	f/4	"	f/4	"
20	f/4	"	f/4	"

After you have completed take II, make sure that your color-processing laboratory numbers the individuals mounts sequentially. This is very important, as it enables

Fig. 2-3. Take II.

you to study the transparencies and correlate them with the frame numbers on your chart so that you can comprehend how all the various elements interact.

When your slides are back from processing, study them carefully. There are four ways to look at them:

1. Hold them up and look at them with a light behind them.

2. Put them on a slide sorter or light box (Fig. 2-4). These cost from $10 to $30 or more. An inexpensive one is adequate for your present purpose. Spread the slides out in numerical order and study them along with your exposure chart. The advantage of using the slide sorter is that you can look at a whole roll at once and see the effect of all the variations. A magnifying glass can be helpful. Subsequently, you might want to study the slides individually.

3. Put them on a slide viewer with a magnifier; the slides are lighted up one at a time, and enlarged two times or more.

4. Use a slide projector, which is the most exciting way of seeing slides, even "bad" ones. Very often, when you are projecting slides you discover things in them you wouldn't see if you viewed the slides the three other ways.

Time spent studying your slides is time well spent. You can derive new ideas, decide what you would like to change, and discover the effect the two takes have on each other. You can determine what kind of an exposure-bracketing spread you want. You may decide to eliminate one or

Fig. 2-4. The slide sorter.

two of the aperture openings, or use them only in special cases.

If you have followed instructions carefully, your results should look something like Fig. 2-5.

An exposure in which the image of take I is brighter than the image of take II may provoke a mood totally different from the reverse combination. The brighter slides could be interpreted as being gay, dreamy, or happy. The darker images may create a mood that is mysterious, ominous, or sad. You will eventually learn how to control and create images to impart a specific mood and emotional quality. So the "correct" exposure is not necessarily what we are after, but rather an exposure that gives us what we are trying to achieve or "paint." Right now, even so-called mistakes can be a way of discovering the limits and outermost boundaries we can reach. Ideally, you will be satisfied with your first results. You will see what you can do, and you will be encouraged to go on to your second roll.

SECOND DOUBLE-EXPOSURE SHOOTING

The directions for the first shooting may seem to be very disciplined and rule-bound, but in this kind of photography, where the accidental can play such an important role, where the range of possible combinations can be endless, loose, and wild, I think it is best to operate from a

strong base, slowly and carefully. The seemingly simple double-exposing of heads has many variations. It is like the surface ripples that go on and on when you drop a stone into a pond.

You should refer to the exposure charts in the previous section before you start shooting the projects presented in this section. Copy the form used for the exposure charts, and fill in the aperture and time settings after you take your exposure readings.

Also, make sure you mark the film with your ballpoint pen when you load the camera. This should become automatic. You may not expect to double-expose, however if your film is marked, you will be able to double-expose accurately, should you decide later that you want to double-expose.

Below are diagrams to follow for this shooting; after this, however, you will be making your own diagrams. The exposure charts, the diagrams, and the notes you make will prove to be very important and valuable to you.

For this shooting you will need all the things listed earlier in this chapter, except this time you'll use a 36-exposure roll of film as to have more leeway.

Fig. 2-5. Take I and take II on the same frame. Each take fills up the dark area of the other.

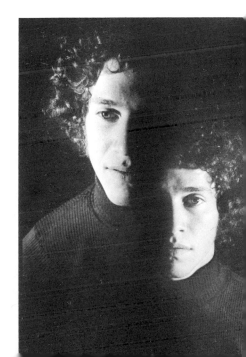

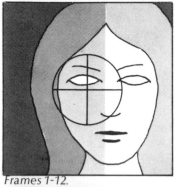

Frames 1-12.

Fig. 2-6. Frames 1 to 12 of take I are close-up shots of the face, frames 13 to 24 are profile shots. For frames 25 to 36, move back with the camera so the face occupies a smaller area of the picture. If you like, you can change the color of the scrim every six frames.

Frames 13-24. Frames 25-36.

If your lens does not focus close enough to fill up the whole vertical-frame area with a head, you will need a close-up attachment. (Costs vary from approximately $5 to $20.)

Place a colored-gelatin scrim, or attach loose sheets of colored cellophane, on your light reflector with masking tape. Use any color you wish.

Start this shooting the same way you started the first shooting. Your model is seated in front of a dark background. Place the light to the model's left, as you did in the first shooting. Take your light reading, and fill in the aperture and time settings on your exposure chart for frames 1 through 12. If you have decided to limit your bracketing spread after studying the results of your first roll, do it now; but I assume you will want to do some bracketing. For frames 13 through 24, turn your model around for a profile. If you have changed the scrim, check your light reading. Fill in the aperture and time settings on your

chart. For frames 25 through 36, remove the close-up attachment and move back with your camera. Again, take an exposure reading and fill in the aperture and time settings on your exposure chart.

Now we are ready for take II. Retract the film, check the lines you drew on it near the leader, and move it up to frame No. 1. Move the light around to the model's right, and pick one of the following suggestions, or anything you think of yourself. Don't worry if some of your efforts fail. This is a time of learning, and you can learn a lot from mistakes.

I should also like to tell you that all these shots can be done with a normal lens; so if you don't have a close-up attachment, don't let that stop you. Your closeups may not match the diagram, but they will be good enough. As for the long shots that are on the following list of suggestions, I don't know what kind of a space you will be working in, but I presume that you will be able to get far enough away from your model to be able to shoot with a normal lens. However, for more spread and more flexibility, now and later on, it would be good to have close-up attachments; or, if you're lucky, a close-up lens and also a wide-angle lens

Fig. 2-7. A different person was used for the second take in this double exposure.

Fig. 2-8. The slightly out-of-focus young man and the halo around the girl give this double exposure a dreamlike quality.

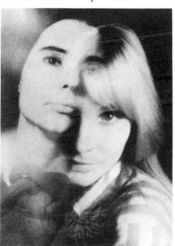
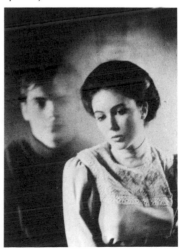

Substituting a 35 mm focal length lens for your normal lens while shooting gives you something extra to work with, and I have found that it even stimulates new ideas.

Suggestions for Take II's

1. Do the same size heads, lighted, of course, from the opposite side, with different colored scrims and with the highlighted side of take II right on top of the shadow side of take I, so that the two highlighted sides are close. Throw some of the frames out of focus.
2. Put the model in a costume and do a medium or long shot.
3. Use a second model, someone of the opposite sex or a child or a much older person, and make close-up, medium, and long shots (Fig. 2-7).
4. Remove the camera from the tripod, put the time setting on a slower speed (1/15 sec., or 1/10 sec., or 1/5 sec.), and introduce camera movement. In this case, remember to compensate for the slower speeds with smaller apertures.
5. Try a piece of clear but slightly crumpled cellophane in front of the lens to get a diffused, hazy effect (Fig. 2-8).

PROCESSING YOUR OWN FILM

Since this book is primarily concerned with color-slide projects, you might consider processing your own color-slide film. Any color film labeled "E-6 processing" can be finished in your own darkroom. If you can process black-and-white film, you can feel confident about being able to handle color processing.

Several kits for home processing are available in camera stores. They come with detailed instructions, but it is a good idea to study a manual about color processing before undertaking the processing.

Some points to think about:
- It is recommended that you buy at least four rolls of film to process at a time.
- You need a supply of hot water for a bath temperature between 33 C and 39 C (92 F and 102 F).

Equipment needed consists of:
1. Loading reels.
2. A tank.
3. A thermometer.
4. A pair of scissors.
5. A funnel.
6. A 1-pint graduate.
7. A 1-quart graduate.
8. Six dark brown 1-pint glass bottles.
9. A deep plastic dishpan that will hold 1½ gallons of water.
10. A pair of plastic or rubber gloves.
11. Mounts to hold the finished slides.

Members of some camera clubs buy their color film together in bulk, load the cassettes, and process the film together. This effects quite a savings in cost.

3

Abstractions

Making *abstractions* with color film is an easy way to make beautiful slides and to have fun, as the possibilities are endless.

Besides being beautiful, and a joy to create, abstractions are useful to have on hand for making "sandwiches," one of the techniques you will read about later in this book. Abstractions are also useful if you plan to put together slide shows.

If you look around carefully you can see that there is not too much natural color in the world; most of the color you do see has been created and added by people, with makeup, clothing, signs, printed matter, and paint. So, too, we can add an extra dimension to our slides by adding color. We can feed extra color into the shadow areas of the first takes and fill up dark backgrounds with shapes and color. Abstractions can vary from a single color with highlights to a collection of wild colors; and they can either be amorphous or geometric.

There are several ways to make abstractions. You can use the camera and color film to obliterate the reality of anything you photograph by going extremely out of focus, or by using a slow time setting and moving the camera.

You can also have various objects and materials on hand and make an infinite variety of abstractions quickly and easily. These materials should have lots of color along with surfaces that will give you lots of glints and highlights.

Handy Objects for Making Abstractions:

1. Posters
2. Fabrics with strong designs and colors
3. Brightly colored paper
4. Christmas-tree balls and lights
5. Sequins
6. Rolls of colored foil or gift-wrapping papers
7. Aluminum foil
8. Rolls of clear, colored cellophane

The posters and fabrics can be photographed directly out of focus, with a slow time setting. You can do the same with the colored paper, balls, and sequins if you scatter them on a dark background. The foil, cellophane, and gift-wrapping paper can be crumpled and carefully lighted so that you get highlights and gradations of tones for making abstracts of single colors. Again, you should be out of focus. You might take several thicknesses of the cellophane, either one color or several colors, crumple them, and place a light behind them. Here you must be careful with your light reading, as everything tends to be very bright and you can easily overexpose. The Christmas-tree lights can be taped on a black background. In taking the

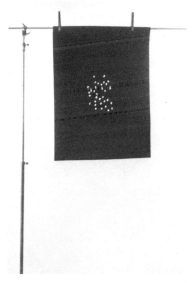

Fig. 3-1. The "abstraction maker" attached to the horizontal bar of a light stand. Each hole in the central area of the sheet of black paper is backed by colored cellophane; a bright light shining through the holes enables the photographer to create colorful graphics.

picture, I almost invariably set my camera speed on Time and move the camera.

I made my own special, favorite "abstraction maker," and with it I get results similar to those you get with the Christmas-tree lights. In the center of an 46 × 61 cm (18" × 24") black sheet of paper, I punch a cluster of 3 mm (⅛") holes. Each hole is backed with a small piece of colored a cellophane. I attach the "abstraction maker" with masking tape to the horizontal bar of a light stand. I place a light behind it. This light is usually a 250-watt bulb in a 30 cm (12") reflector. There are three things I usually do when I use the "abstraction maker":

1. I get very close to it, go very much out of focus, and get large, soft, overlapping circles of color.

2. I move to a position where the frame is filled with the dots of color, use a sharp focus or a slightly soft focus, and get an abstract slide of color dots.

3. I set the aperture at $f/16$ and the shutter speed on one second, or Time (counting out two or three seconds), and deliberately move the camera around.

If you want to move the camera, there are several kinds of movements you can make. You can zigzag the camera. You can make horizontal, vertical, diagonal, wavy, erratic, jerky, and nervous quivering movements. You can hold still for part of the exposure and quickly jerk the camera for the balance of the exposure. Or you can move in and out, to and from the board, during the exposure. When you make these movements, you are using the color dots to "draw" on the film, making lines of color and controlling the design. You will find that this is not the only circumstance in which these deliberate camera movements are applicable. Later on in the book we will come to others.

You can manipulate the light by changing the size of the bulb and also the distance between the back of the board and the light. It is difficult to get an accurate light reading off the board; I do it by putting the meter very close to one of the holes, then to another and another, until I have some kind of average reading. After you see your first results, you will have a good idea of what your exposures should be, and then, obviously, you can have a record of the exposures, the bulb sizes, and the distances between the light and the holes.

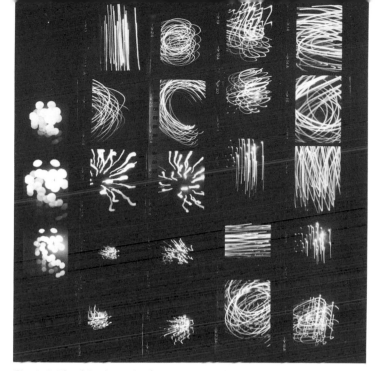

Fig. 3-2. This black-and-white contact sheet illustrates
the kind of photographs which can be made with the
"abstraction maker." Keeping the camera focused on
the lights while using the time-exposure setting and
varying degrees of camera movement will yield
streaky patterns. Keeping the camera still, but going
very much out of focus, will yield diffused dots. In
color, of course the abstraction-like effects are en-
hanced.

All the instructions given above for the "abstraction
maker" can be applied to Christmas-tree lights taped to a
black board. Records of the exposures should be kept.
With the Christmas-tree lights, however, you cannot con-
trol the amount of light the way you can with the "ab-
straction maker," as the light from the bulbs is constant.

While working with abstracts, always press the
depth-of-field preview button to see what things look like
at the aperture at which you will be shooting. This is im-
portant: If you are too much in focus, you can destroy the
illusion. In photography we often struggle to get sharp
focus, but sometimes, surprisingly, when making abstrac-
tion and other subject matter, we may want to go out of
focus; and we may find that we have some difficulty

achieving this. I have sometimes resorted to putting a close-up attachment on the lens to ensure out-of-focus results. But remember, if you are too far out of focus it can be too mushy and formless; so always use your preview button.

Another problem that can arise when making abstract slides is that sometimes you may have too much light, especially when you are shooting on a time exposure. For instance, with the black board with the holes in it, or particularly with the Christmas-tree lights, I have shot at f/16 for as much as four seconds in order to have extra time for camera movement and have cut down on the aperture by laying one or two spread fingers across the lens while exposing. This also affects the design; the results are quite interesting because you can't anticipate them. I've used the two-finger technique at other times too, especially when I've put the camera close to a neon sign at eye level.

USE OF REFLECTIVE SURFACES FOR ABSTRACTIONS

Another way to create effective and unique abstractions is to take the aforementioned objects and photograph their reflections in different types of reflective surfaces. Each reflective surface has its own characteristics and does its own special thing for you.

In this chapter we'll examine reflective surfaces, as well as a device for creating abstracts only; but in later chapters we'll review the use of reflective surfaces for other projects.

Reflective Surfaces

1. Highly polished and shiny metal surfaces and objects, such as stainless steel, aluminum, silver, and the like.

There are an immense number of these objects around us in our daily lives: We have all seen those wonderful photographs that tableware and pot-and-pan manufacturers run as ads. If you look closely at these pictures you will see, on the metal objects, abstract designs that are

in reality reflections of the studios in which the photographs were made. These reflections are distortions created because of the shapes of the metal objects. Any such shiny metal object (which I'm sure you have) could be used to reflect colors, or other objects you place in front of them, and you could then photograph these reflections to create abstract color transparencies. You might want to get a sheet of metal stamped with geometric designs, the sort of thing you see on walls around stoves in restaurants.

2. Stiff, semistiff, and soft reflective plastic materials, such as Mylar and polystyrene.

These are only two among many types of shiny plastics in various degrees of thickness and stiffness. Mylar, a soft plastic, has become a common material that can be purchased in art stores. I got several sheets of polystyrene (aluminum) .010″ thick from Coating Products, Inc., of Englewood Cliffs, New Jersey. I made extensive use of this material, which comes in colors other than the silver aluminum. I hung it from the horizontal bar of a light stand that can be adjusted to a convenient height for shooting. When being photographed at slow speeds, both the Mylar and the polystyrene will shimmer and undulate, creating interesting effects out of the colors reflected in them (Fig. 3-3). These plastic materials can also be bent and creased and made into tubes, arcs, and funnels. Colored objects become soft and flowing when reflected in these surfaces, like watercolor washes.

3. Mirrors—plain, curved, smoky, concave, convex, broken, or geometrically designed or cut.

Bear in mind that the flat mirror does not distort. The results you get with it aren't too different from photographing your abstract-making materials directly, except that it will double the distance between the reflected object and the camera, if that is necessary, and give you additional scope in a tight area. However, as the surface of the mirror deviates from being flat and level, so does it distort, and distortion is an important element of abstraction.

A broken mirror can be an extremely effective device for creating abstracts, but it also has many other very important applications and uses, which I will describe later. Right now, though, I'd like to tell you how to make a broken mirror and suggest ways you can use it to make abstracts.

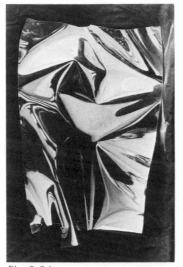

Fig. 3-3A.

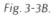

Fig. 3-3B.

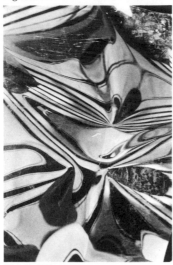

Fig. 3-3C.

Fig. 3-3A is a bent sheet of polystyrene attached to a black cloth. Fig. 3-3B is a piece of black-and-white striped fabric. In Fig. 3-3C the reflection of the striped fabric in the polystyrene becomes an interesting composition.

Making a Good Usable Broken Mirror

With rubber cement, glue an 28 × 36 cm (11″ × 14″) mirror on a piece of black cloth larger by 10 cm (four inches) on three sides and 20 cm (eight inches) on the top. The cloth should not be tautly stretched. After the rubber cement is thoroughly dry and the mirror and the cloth are firmly glued together, put a folded towel under the cloth

and a layer of newspapers on top of the mirror and hit the mirror near the center with a hammer. You will get a spider-web design of cracks radiating out from where the glass was hit.

Staple the long side of the cloth to a stick; leave small pleats between the staples so that the broken mirror will have some flexibility. What you will have is a kind of flag. The long end of the stick can be attached to the horizontal bar of a light stand with masking tape or clamps, and the mirror (or the flag part) will hang down. You could have a broken mirror that was hit in several places so that the web of broken lines would be jumbled. Or you could make a designed broken mirror: With a glass cutter, you could scratch the mirror exactly where you want the breaks to occur.

With a broken mirror, you can focus:

1. On the surface of the mirror, the broken cuts creating a webbed pattern over the out-of-focus reflected colors or objects.

2. On the distorted jumbled reflection, losing the out-of-focus webbed pattern of the breaks.

3. In between the surface of the broken mirror and the reflection, just getting an indication of the webbed design of the breaks as an overlay on the reflection.

Before shooting, turn your focusing ring back and forth and study all the different effects. Remember, reflective materials will increase the range of possible abstractions.

USE OF GLASS DEVICES
TO CREATE ABSTRACTIONS

Glass devices also change and distort the reality of the materials and objects you photograph. Like reflective surfaces, they can be used for subject matter other than abstractions, and that will be explained later in the book. Glass devices are used anywhere from right in front of the lens all the way to the object being photographed. Start off with any of the materials listed earlier. You might, for example, set up a poster, since it is fairly large, or a large piece of printed fabric, and use the glass device to create unusual effects. Do not put the camera on a tripod, because you should be free to move back and forth, playing with

Fig. 3-4A.

Fig. 3-4B.

Fig. 3-4C.

Fig. 3-4D.

Fig. 3-4E.

Fig. 3-4F.

Fig. 3-4G.

Fig. 3-4 is a mirror hit only once, resulting in a simple pattern of breaks. Fig. 3-4B is a mirror hit several times, resulting in a complicated pattern of breaks. Fig. 3-4C shows a black-and-white striped fabric, to be reflected in both types of broken mirrors. In Fig. 3-4D the simple pattern of cracks is in focus and the fabric stripes are out of focus. In Fig. 3-4E the simple pattern of cracks is out of focus, while the stripes are in focus. In Fig. 3-4F the complex pattern of breaks is in focus and the fabric is out of focus. In fig. 3-4G the fabric is in focus while the busy pattern of breaks is out of focus.

the different devices and trying several of them to see and experience the different results.

Glass Devices

 1. Flat patterned glass
 2. Window glass
 3. Prisms
 4. Cut-crystal or pressed-glass objects
 5. Magnifying glass

1. Flat Patterned Glass. If you go to a glazier's shop you will find all kinds of patterned glass, from very slightly patterned glass to busy, complicated patterns. Several pieces of this kind of glass, both large and small, are handy to have. To prevent cutting yourself when handling the glass, either sandpaper or tape the edges.

To work with a large piece of glass, set it up somewhere between the camera and the object you are photographing. I use a wooden chair, rest the glass on the seat, and hold the glass firmly upright by a clamp to one of the vertical slats of the chair. You could also place the glass in a picture frame and rest the frame and the glass on the chair. As I said earlier, these devices have applications in later work, so if you go to any trouble to get the materials and the setups, remember you will have additional uses for them.

If you want to start off with just a small piece of glass, simply hold it in your hand and move it back and forth in front of the lens.

2. Window Glass. If you have a large piece, you can paste all kinds of things on it—small pieces of colored cellophane, sequins, glass gems, and so on. Use it in the same way as the flat patterned glass.

3. Prisms. If you have a prism, hold it in front of the lens and keep turning it around. You will see that it gives you rainbows on the highlights and edges of things, especially highly polished metal objects and crumpled foil. Be careful of your exposures when using a prism, as it lowers the light.

4. Cut-Crystal and Pressed-Glass Objects. These devices, moved back and forth and angled different ways in

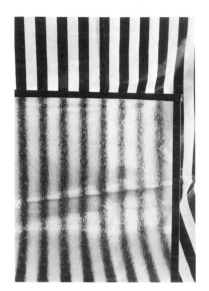

Fig. 3-5A (left). The effect created by flat, finely patterned glass.

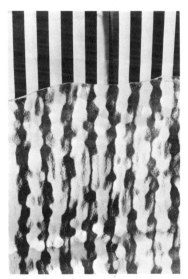

Fig. 3-5B (right). The effect created by flat glass with a broader pattern.

front of the lens, will do the same thing as a prism. The facets are in effect many prisms, so you will have jumbled and multiplied rainbows. In addition, you will have all kinds of indefinable extra images.

Automobile-headlight covers are disks of pressed glass with interesting designs. I found a large automobile-headlight cover with concentric circles crossed by lines

going out from the center. I used it in front of the Christmas-tree lights and had an effective take II for a series I did on a girl and a boy dancing.

5. *Magnifying Glass.* This has its own characteristics, which you will enjoy discovering. It diffuses the focus unevenly; and if you have some extra lights around while shooting, even ordinary ones like a ceiling light or a reading lamp, the magnifying lens will pick up highlighted spots. If you have an enlarger, take out one of the condensing lenses. They are in effect rather large magnifying lenses, and they can create some unique distortions.

All the foregoing information deals with ways and means to make abstractions inside, under controlled conditions. There is an endless source of material outside your studio waiting for you to come along with your camera

Fig. 3-6. Some of the devices which can be used in front of the lens— cut crystal, prisms, pressed glass, and a magnifying glass.

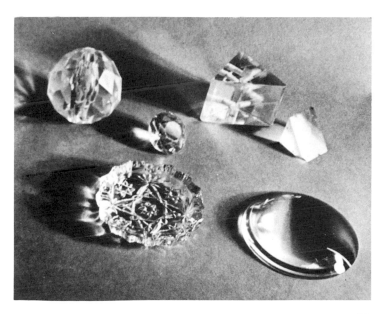

and extract the abstractions. In the next chapter we'll examine some of these materials.

I don't believe there should be too many rules for making abstract slides. For your first couple of rolls, you should keep exposure charts; after that it's up to you whether or not you want to keep exposure records. All you really need are some suggestions, a few guideposts, and then you can just take off and discover your own way. Abstractions are highly personal means of expression, and after you get going on them, they almost begin to make themselves.

You will learn that if your focus is too sharp you will get a slide that is not an abstraction, but a dull picture of broken mirrors, sequins, pieces of paper, or whatever. You will realize that in creating abstractions, you can go from a wildly contrasty range of color to subtle variations of one or two colors. But, as you go along, working, trying this combined with that, somewhere you will find a whole range of your own.

4

Reflective Surfaces

MIRRORS

The use of mirrors and other reflective surfaces to distort and change the appearance of objects and thus create abstractions was introduced in the previous chapter. In this chapter we will discuss how mirrors can be used to emphasize—not distort—some of the characteristics of what is being photographed.

Use of Mirror in Photographic Situations

One basic use of the mirror in photography, easily overlooked, is that it doubles the distance from the reflected image to the camera. The photographer can stand practically side by side with a model in a small place, both of them facing a mirror. The photographer, the model, and the mirror can be thought of as standing at the three points of a triangle, and if the model-mirror-photographer angle were widened, like a folding ruler, the model would end up at one end and the photographer at the other, making a clear shot possible. Generally, however, when shooting into a mirror the photographer can easily be reflected into the camera along with the model; either allow it to happen knowingly, or take care to avoid it. Also, the photographer must be aware that a mirror cuts down on the light reading (Fig. 4-1).

Another fact to consider is the influence of the mirror on the model. Something special happens when the model looks into the mirror. It releases tension—the feeling of being a fish at the end of a line or a marionette—and

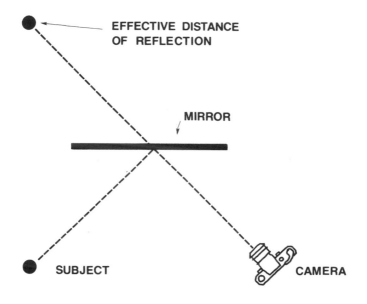

Fig. 4-1. When using a mirror to take pictures, it is important to remember that the effective photographer-model distance is greatly increased. This will not only change the point of focus, it will also cut down on the light reading.

makes the model feel less at the mercy of the person with the camera. This feeling can be unnerving and uncomfortable. When looking into the mirror, the model's self-awareness is reinforced, and the relationship between the photographer and the model is equalized. It gives the model a freer feeling, and thus makes for a better working mood.

Types of Mirrors

1. Small mirrors
2. Large mirrors
3. Broken mirrors
4. Convex mirrors
5. Mirror setups
6. Mirrors of designed and geometric cuts

1. Small Mirrors. You could take a small mirror, glue it on an opaque surface, on a design, on a painting, on a large poster, or on a photograph of a person or a scene, have someone's face reflected in the mirror, and then photograph the whole thing. The person's face reflected in the mirror has found a new environment, an environment that is totally under your control.

I glued a small mirror on a board, and then glued rose-colored sequins all around the mirror (Fig. 4-2). A girl's face was reflected in the mirror and the sequins, which were out of focus, gave a shimmering effect; the face appeared to be floating in this indefinable pinkish sea

2. Large Mirror. If you have a large mirror, think in terms of pasting various things on the surface, either scattered or closely bunched together.

Figs. 4-2. *Rose-colored sequins are pasted around the small mirror. The sequins and the face are lighted so both will show up in the picture. In the shot resulting from this setup the models face appears to be floating in a sea of blurs. (See color section.)*

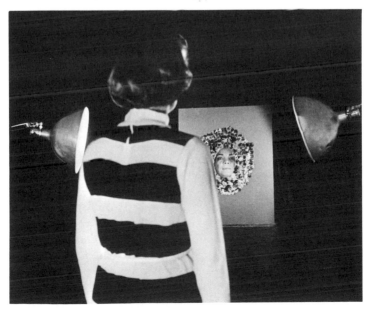

Some of the things to put on the surface of the mirror:

a. Small pieces of cellophane, clear or colored
b. Stained glass
c. Lace patterns
d. Drawings made with grease pencils
e. Colored sequins, or small pieces of gold, silver, or colored gilt paper
f. Artificial flowers and leaves
g. Translucent decals

Again, I will not give specific detailed instructions, but general descriptions. Put any one of these items on the mirror, and use it in conjunction with one or two people. Study the overall effect through the camera in close-up, medium, and long shots. If you are working with two people, you might have one facing the camera and the other one facing the mirror. Alter the distance from person to mirror, or photographer to mirror. Try different depths of focus and different lighting effects.

You can do a take I of a person, and then do a take II of the same person reflected in a mirror. If you combine a person with his reflection, mix soft focus with sharp focus, and use different lighting effects, you can get a whole series of variations.

You can also get several mirrors and set them up at slightly different angles, or imitate the three-sided mirror setups in the fitting rooms of clothing stores.

3. *Broken Mirrors.* I paid at least six months' rent with earnings from work I produced using a broken mirror (directions for making it appear earlier). A broken mirror does many things to a face. Again, invite your patient and loving friend to the studio and set up your broken mirror. If you look through your camera at the face reflected in the broken mirror and just move around very slowly, you will see that the reflected face will go slightly out of kilter, then one or two features will become multiplied or fragmented, until finally the entire face will become torn apart and almost obliterated. Every 6 mm (¼″) that you shift can give you a totally different distortion and composition. Try your close-up attachment on the lens; also try a wide-angle lens. Remember, you can, if you like, get the fragmented

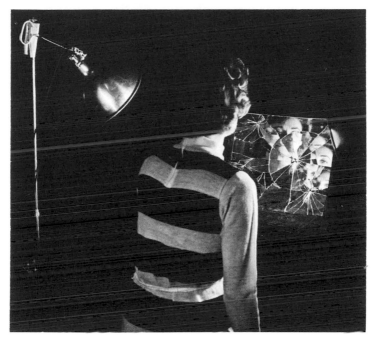

Fig. 4-3. Setup with the broken mirror, showing the fragmentation of the image.

effect you want, without giving away the fact that you used a broken mirror, by focusing on the reflections. The lines of the breaks will then blur.

I made two similar photographs with the broken mirror, one of a woman's face and the other of a man's face. Both were closeups and double exposed on abstracts. Moving around with my camera, studying the reflections of the man and the woman, I found one point at which the cracks in the mirror caught the upper part of their faces and swept it up, multiplying the area of the eyes about six times. The impact of this distortion was such that the pictures expressed something that could be interpreted as fear, awe, or extreme puzzlement.

Once I had an assignment to photograph the work of Sabra Moore, a sculptress. She had one very arresting piece which she called "Mask-Woman"—a white distorted face, with large painted red lips and very realistic protrud-

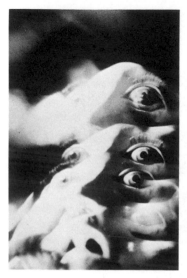 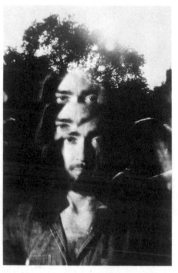

Fig. 4-4. A "Mask-Woman" sculpture reflected in the broken mirror.

Fig. 4-5. A man's fragmented face double exposed over a shot of the sun setting in the trees.

ing artificial glass eyes ringed by thick false eyelashes. Even as it was, it was quite a shocker, but reflected in a broken mirror, with fragmented and multiplied features, the horror of it was intensified; in addition, it appeared to be reacting to something horrible. I also photographed "Mask-Woman" reflected in plastic material; this stretched the head lengthwise and made it seem to undulate, with one eye coming forward in sharp focus and the rest of the face still discernible but slowly melting into out of focus, like one of Salvador Dali's soft watches (Fig. 4-4). I also double-exposed this grotesque white face with an abstraction, mainly to feed color into it.

4. *Convex Mirrors.* I have never been able to do anything with concave mirrors, but you might want to try them. I like to work with convex mirrors. (Definition of convex: curved like the outside surface of a sphere. Definition of concave: curved like the inside surface of a sphere.) What follows is a description of two projects of mine that you might like to repeat.

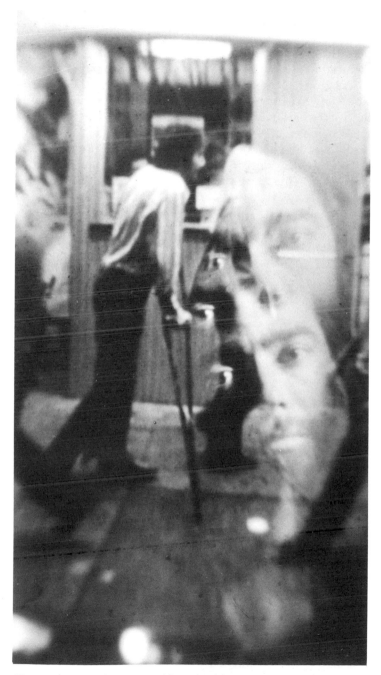

Fig. 4-6. A man's fragmented face double exposed on a New York City scene.

I used convex mirrors on an assignment for a science-fiction book which had to do with cities that had been detached from the earth and were floating in space. I had noticed that trucks often have a convex mirror about 10 cm (four inches) in diameter attached to the driver's side-view mirror, which gives him a wide-angle view of the road similar to the wide view you get with a wide-angle camera lens. You have also seen convex mirrors in stores and elevators. These mirrors can be purchased in auto-accessory stores. I bought four circular ones and glued them on a 36 × 43 cm (14″ × 17″) black illustration board (Fig. 4-7A).

Fig. 4-7A. Four large convex mirrors mounted on a black board.

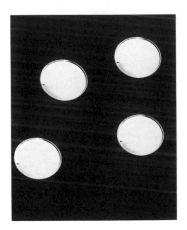

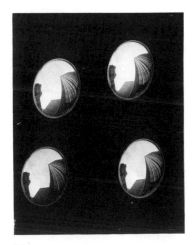

Fig. 4-7B. The same four convex mirrors with reflections of city buildings and the sky.

With a "prepared" roll of film in the camera, I went to the roof of a building that had a good view of the skyline. I rested the board on a chair and photographed it, filling up the viewfinder with the whole of the black cardboard. The four convex mirrors reflected a view of the city. Beams from the sun bounced off the convex mirrors in sharp rays. Since it is hard to get a proper exposure reading off a convex mirror, the bracketing was very wide: two stops both over and under the reading, with half-stops in between. The focus was as sharp as possible, though it is difficult to focus sharply on the image in a convex mirror. Although shooting outdoors, I used the High Speed Ektachrome Film (Tungsten) available at the time, which was balanced for indoor shooting and which shifted to the blue side when used outdoors. I wanted a predominantly blue tonality in order to reinforce the effect of outer space. I had planned to do my take II on "space" indoors. I created "space" by laying crumpled blue cellophane on top of blue paper, lighted from the side for highlights. I didn't use the real sky because the city sky isn't blue enough, and even in the country I might not have been able to get the exact shade of blue I wanted when I was ready to shoot. By using blue cellophane and blue paper, I could get a strong shade of blue. The exposure bracketing for the "sky" was not as wide as for the "cities," but I shot with variations in the focusing.

The effect that these were cities whirling through space was enhanced in the slides, where the exposure of the "cities" was strong and the "sky" was semi-out-of-focus and slightly overexposed. The "sky" filled up the unexposed area of the black cardboard and spilled over sufficiently into the reflections of the "cities" to blur the outline of the convex mirrors.

If you study the chart you can see that I tried to get as many different combinations of exposures as I could on a 36-exposure roll. If you start with your basic light reading, and you have some idea of the image you wish to capture in your photograph, you usually get a result if you take care of covering all the technical aspects. Sometimes the results can be even better than anticipated.

After the success of the "cities in space" project I wanted to continue working with convex mirrors just for my own pleasure. I took a convex rectangular mirror with

EXPOSURE CHART

(Light reading for Take I, cities reflected in convex mirrors, f/8 at 1/125 sec.)
(Light reading for Take II, in-studio "Sky," f̄/5.6 at 1/60 sec.)

Frame #	Take I		Take II	
1	f/8	1/125 sec.	f/5.6	1/60 sec.
2	f/8	"	f/4–5.6	"
3	f/8–11	"	f/4	
4	f/11	"	f/2.8–4	"
5	f/11–16	"	f/2.8	"
6	f/16	"	f/2.8–4	"
7	f/11–16	"	f/4	"
8	f/11	"	f/4–5.6	"
9	f/8–11	"	f/5.6	"
10	f/8	"	f/5.6–8	"
11	f/8	"	f/8	"
12	f/5.6–8	"	f/8–11	"
13	f/5.6	"	f/11	"
14	f/4–5.6	"	f/8–11	"
15	f/4	"	f/8	"
16	f/4–5.6	"	4/5.6–8	"
17	f/5.6	"	f/5.6	"
18	f/5.6–8	"	f/4–5.6	"
19	f/8	1/125 sec.	f/4	1/60 sec.
20	f/8	"	f/4–5.6	"
21	f/8	"	f/5.6	"
22	f/8–11	"	f/5.6–8	"
23	f/11	"	f/8	"
24	f/11–16	"	f/8–11	"
25	f/16	"	f/11	"
26	f/11–16	"	f/8–11	"
27	f/11	"	f/8	"
28	f/8–11	"	f/5.6–8	"
29	f/8	"	f/5.6	"
30	f/8	"	f/5.6	"
31	f/5.6–8	"	f/4–5.6	"
32	f/5.6	"	f/4	"
33	f/5.6	"	f/2.8–4	"
34	f/4–5.6	"	f/2.8	"
35	f/4	"	f/5.6	"
36	f/4–5.6	"	f/8	"

rounded corners that was approximately 13 × 18 cm (5″ × 7″) and mounted it on a black cardboard. A friend came with me and held the mirror. We walked around New York City. She held the board out like a tray, tilting it when necessary, and I bent down and photographed the skyscrapers reflected in the convex mirror. The reflections

curved in from wide bases to very narrow, almost pointed, tops (Fig. 4-8). I also photographed traffic and people coming down the street. It was like having a cheap fisheye lens. And with the mirror you have the added possibility of tilting to experiment with. For this series of pictures, I used Ektachrome daylight film, black-and-white film, and infrared color film. The infrared made the city a rosy, pinkish, pretty place. I double exposed about a quarter of the roll, but in this case the double exposure did not enhance the subject and the single takes were better.

5. *Mirror Setups.* Mirrors reflect what is, but several mirrors placed at angles to each other will reflect the reflections *ad infinitum* and take us right out of reality into endlessness.

I used three 28 × 36 cm (11″ × 14″) mirrors to produce photographs for two science-fiction book covers dealing with timelessness. I placed one mirror on a table and made a tentlike structure with the other two mirrors, holding them together with Scotch tape.

One of the books for which I created this setup was about a new species of "man" that lived in timelessness. I

Fig. 4-8. The rectangular convex mirror reflecting the tops of tall buildings on the Avenue of the Americas in New York City.

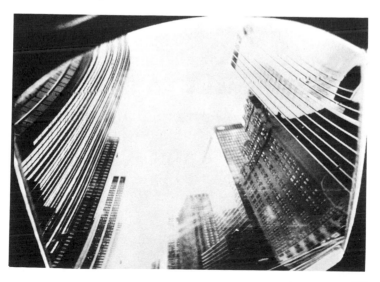

found a small tin wind-up toy in the 5 & 10. It had a large head, no neck, an oval chest, very thin arms, and long heavy legs. I altered it slightly by bending the arms and hung it by a thread from the center of the "infinity" tent. I gave the little man suspended inside the tent an environment of colored sequins, broken glass, small pieces of mirror, prisms, pieces of faceted pressed glass, glass doorknobs, marbles, and pieces of foil paper. I also put some crumpled cellophane, in all colors, on the mirrored floor and pasted some on the mirrored walls (Fig. 4-9). Everything was reflected back and forth from one mirrored surface to the other like an eternally resounding echo. I threw a spotlight on the this setup and kept studying all the different compositions created by just bringing any one of the many different reflections into focus, backed and fronted by vague, similar, out-of-focus reflections. It was important to make sure I had a very shallow depth of field so that I could suggest a new kind of reality without at the same time revealing the actual fact of what I was shooting. Take

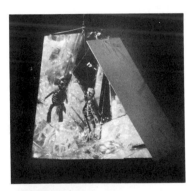

Fig. 4-9 (Left). The "infinity tent" setup.

Fig. 4-10 (Below). Portrait made with mirrored tube.

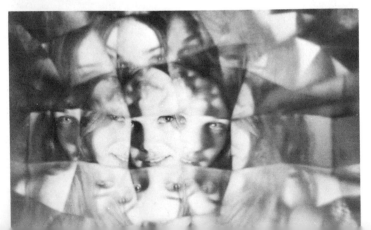

II was crumpled red foil paper, out of focus, to fill in all the shadow and dark areas with an atmosphere of "flames."

I don't expect you to follow my shootings step by step, though you can if you want to. I just want to present you with some examples of what I do in order to impart some of my experiences and perhaps help you to go on and do your own thing.

6. *Mirrors of Designed and Geometric Cuts.* In window displays I had noticed mirrors made of little squares like graph paper, and by inquiring I discovered Parallel Manufacturing Corporation, in New York City. This firm specializes in cloth-backed cut mirrors, which it calls *Paraflex.* Paraflex comes in square cuts, parallel cuts, and diamond-shaped cuts and, as the name indicates, it is flexible. I specifically sought out this company because I wanted a square tube and a six-sided tube mirrored on the inside to fit over my lens and extend out from it. Parallel makes products for window displays, interior decorating, lamp bases, picture frames, novelty boxes, and so on. The company also does custom work for photographers and will make specially cut sheets and mirrored tubes. I got the idea for the home-made cloth-backed broken mirrors from Paraflex. I bought several sheets of the following: 13 mm (½") and 25 mm (1") square cuts, 13 mm (½") 25 mm (1", and 38 mm (1½" parallel cuts.

I cut through the cloth backing of the parallel-cut mirrors and fit the long slender pieces of mirror inside a square tube. This fit over the lens and was large enough to extend back to the body of the camera; it bounced the image back and forth and exploded it out from the center. In the picture, the model is in the center, unreflected, surrounded by a burst of repeated reflections. The tubes I made were 36 cm and 41 cm (14" and 16") long. I wanted to stay fairly far away from the model, so that her face in the center would be small and I would have plenty of film area for the burst of reflections (Fig. 4-10). You could make progressively shorter tubes, allowing yourself to get closer to the model and have a larger image with fewer reflections.

One of the characteristics of these cloth-backed mirrors is that if they are absolutely flat only a small amount of distortion occurs, and if you have extreme depth of field your reflected image, as well as the geomet-

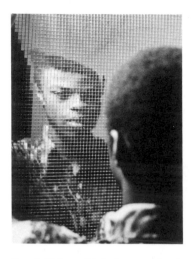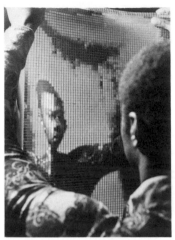

Fig. 4-11A and B. Left portrait of a man reflected in a flat sheet of Paraflex, showing just a little distortion. Right, the man curves the sheet of Paraflex and his reflection is more distorted.

ric cuts on the mirror, will be sharp. Therefore, you can get an image with a clear-cut overlaid design. As the depth of field shrinks, you can either bring the reflection into focus and have the mirror-cuts design hazy over the image or do the reverse, and have sharp geometric cuts over a hazy image. You can also let your focus waver in between, and have both the image and the cuts in equally soft focus.

As soon as this cloth-backed cut mirror is just slightly off a level plane, however, everything reflected in it goes askew, and the cut edges give off all kinds of glints and highlights. I took the 11″ × 14″ sheet of one-inch parallel cuts, stood it up, backed it by a board, held it upright with a small clamp in the center, and let the two sides gently curve to form a concave arc. A girl's face reflected in it became broadened, and one slender vertical area of the face, including one eye, got picked up in the curve and was repeated over and over horizontally.

I was given an assignment to make a transparency for an electric company poster intended to stimulate inter-

est in air conditioners. The art director wanted a photograph which would fit the copy line "Cool Jazz." I photographed a trumpet lying on top of a mirror of 12 mm (½") square cuts. There was a slight distortion, and I felt it looked as if the trumpet was lying on top of ice cubes. I did another take of the trumpet lying on a piece of plain glass, surrounded by real ice cubes. There was a light underneath the glass and one over the trumpet. This was the picture they used for the poster. I felt that the first picture, where the Paraflex was used, looked more like ice cubes and was a better illustration of "Cool Jazz."

PLASTICS

Plastic reflectors vary from being as rigid as glass mirrors to being softer than fabric. These mirrorlike plastics are available in many colors. Sequins, whirling streamers, funny mirrors, and innumerable other things are made of these materials.

A rule you could follow is: The stiffer the plastic material, the truer the reflected image; and the softer the plastic, the more distorted the image, I do not like the extreme way soft plastics distort reflections of people, objects, interiors, or exteriors, although I have seen some wonderful color slides made by other photographers who used soft plastics. I reserve the soft-plastic reflectors for making abstractions, or for backgrounds, where they work wonderfully.

My favorite stiff plastic is a silver polystyrene of .010" thickness. I got several 53 cm × 102 cm (21" × 40") sheets from Coating Products, Inc., of Englewood Cliffs, New Jersey. I used them over and over again. I still have a few of them: Even old, battered, and scratched, they're great, and they do all kinds of special things for me.

When hung like curtains, the stiffer plastics will be almost flat or very slightly curved. The softer plastics can be softly draped. If you touch or hit either one of them, you get a nervous, quivering shimmer, so that light glances off them as it does off water. If you crease or bend the polystyrene, or fold the Mylar, you get lines of strong, glinting highlights at the creases.

Another unique characteristic of plastic reflectors is that you can increase or decrease their distorting qualities by moving around and changing the angle from which you shoot. The distortion increases as the angle from which you shoot becomes more oblique. It is something you will enjoy discovering and playing with.

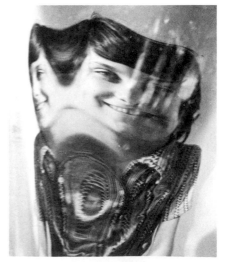

Figs. 4-12A and B. Above, the polystyrene hangs in front of the model and the photographer stands behind the model. Right, the model has bent the polystyrene and the photographer behind her has taken the photo.

Now I'll describe several things I have done—and you can do—with this material using both the 50 mm and 35 mm lenses, and close-up attachments. I hung a piece of polystyrene from the horizontal bar of my light stand with masking tape. This is a convenient way of working with the polystyrene because it can be easily raised, lowered, or rotated to a convenient height and angle.

1. A simple but effective group of pictures I did using the hanging polystyrene and a black background was to have a model reach forward with his hand just short of touching the surface of the plastic. His hand was greatly enlarged, his face was slightly distorted, and he seemed to be trying to ward off something. I double-exposed this on several things:

 a. A large eye from a poster print, also reflected (Fig. 4-13).
 b. A simple, calm, unreflected portrait of the same model.
 c. Abstractions (when in doubt, use abstractions).

2. On an assignment for a cover for a book about three men involved in mysterious dealings, I positioned one man standing, another sitting in a chair, and the third sitting on the floor, all facing the plastic reflector. I did not plan to do a second take on this roll; so I placed one of my lights so that it was also reflected from an angle, with rays of light glancing off the surface of the reflector and filling up part of the background.

While shooting, I varied the degree of distortion by moving and changing my angle, but not to the degree that the identity of the subject matter was lost. As the angle changed, the light beams bouncing off the reflector changed, and in some pictures the men appeared to be standing in the blast of a searchlight.

3. I did something similar with just a man's head in a project for a science-fiction book cover. I used infrared film and kept changing my angle to vary the distortion to a greater degree than in the previous shooting. Because of the film, which caused the face to be green, and the variety of distortions, I had a wide selection from which to choose my cover. In one transparency, the man's eyes ran together in a horizontal line across his face. I did some take II's of Christmas-tree lights reflected off an old creased, scratched, and torn piece of polystyrene in a wild, light-

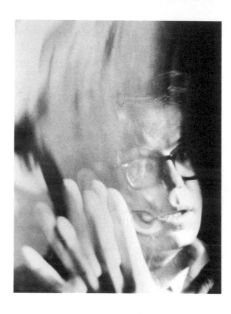

Fig. 4-13. Double exposure of a man reflected in polystyrene and a poster.

ning-like pattern. The infrared film definitely increased the eerie feeling, not only because it made the face green, but also because it made the colors of the lights go all off, especially the reds, which went acid-yellow.

I was so entranced by this torn, scratched, and creased piece of polystyrene that I decided to try additional pictures with it, of this same man and for the same project. It was to be one take. I had the man's face reflected in one small area that was fairly smooth, and behind him the many Christmas lights were picked up by the creases and the bends, and the colors slid around like watercolor washes.

4. The word "mystery" connotes something unexplained, unknown, secret, or covered. To represent this concept visually, people are often made to wear their coats and hats. For photographs, side lighting is often used to create big pockets of shadow. A classic example of this kind of mystery image is the man in the trench coat. This type of thing is exactly what I did for a murder-mystery book cover. I had a man, and a woman in front of him, reflected in polystyrene. They were wearing their coats. This was a long shot. There was strong sidelighting to outline

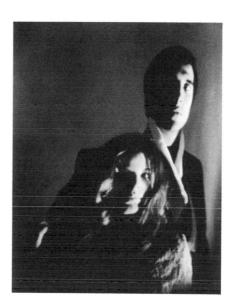

Fig. 4-14. The "mystery"
shot.

them and get a small amount of detail. They appeared to
have just stepped out of darkness. The models were them-
selves fascinated by their reflections and were peering in-
tensely at what they looked like in this setup. These few
elements created the right mood for the mystery-book il-
lustration (Fig. 4-14).

5. A large polystyrene funnel, about 38 cm (15")
long, was used for this next shot. The small end was 3.8 cm
(1½") in diameter and the large end about 38 cm (12"). I in-
tended to use this funnel to isolate the model's eye. It was
very simple to make. I rolled the funnel and taped it. The
model held it in position and I adjusted it a few times, try-
ing it out by looking through its large opening with the
camera. Only his eye was to show through the small end.
The other end had to be large enough so that nothing out-
side it would be included in the frame and so that light
could come through it without being blocked by my head.
With the small end not quite touching the model's face, I
managed to get some light on his eye from the side. The
transparency showed an eye surrounded with a swirl of
light spiraling from the edge of the slide, with the light
swirls getting smaller as they traveled down the inside of

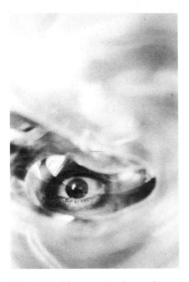

Fig. 4-15. The eye in the poly-
styrene funnel.

Fig. 4-16. The city inside a
teardrop-shaped funnel.

the funnel to the center, where the eye was (Fig. 4-15).

I used a similar funnel, shaped like a teardrop, to isolate and contain a city view for a photograph made from a rooftop (Fig. 4-16). I made the funnel out of black paper. With it, the effect was different. No swirling light, but rather a center subject surrounded by opaqueness on which I could double-expose.

METALS

If you look in the history books, you will find that in ancient times the first mirrors were made of metal. These metal mirrors were very much like ferrotype tins, which are highly polished, smooth, stainless-steel plates. They are used by photographers to dry black-and-white prints and give them a glossy finish. I have used several of these ferrotype tins as reflectors to work out specific problems. For example, I took six of them and hung them vertically, overlapping slightly and not matching the edges. Each was 25 cm × 36 cm (10″ × 14″). I rolled up long pieces of masking tape into balls, adhesive side out, and connected the

Plate 1. The pink haze around the model's face in this photograph is actually pink sequins pasted around a small mirror and photographed out of focus. This technique is discussed in detail in Chapter 4.

Plates 2 and 3. The night shot on the facing page is an example of what can be done with camera movement during exposure. The camera was kept still for most of the long exposure, but moved during the final part. The photograph below is a sandwich of two slides, a portrait of a woman and an Egyptian carving.

Plates 4 and 5. The photograph above was made with the "abstraction maker" described in Chapter 3. This particular pattern of lines was produced by pulling the camera away from the "abstraction maker" during exposure. The photograph below is the result of a combination of many techniques, including multiple exposures and slide sandwiching. It is described in detail in Chapter 9.

Plate 6. The photograph above is an example of the abstractions which can be made from subjects found on the street. These lines are actually part of a neon sign.

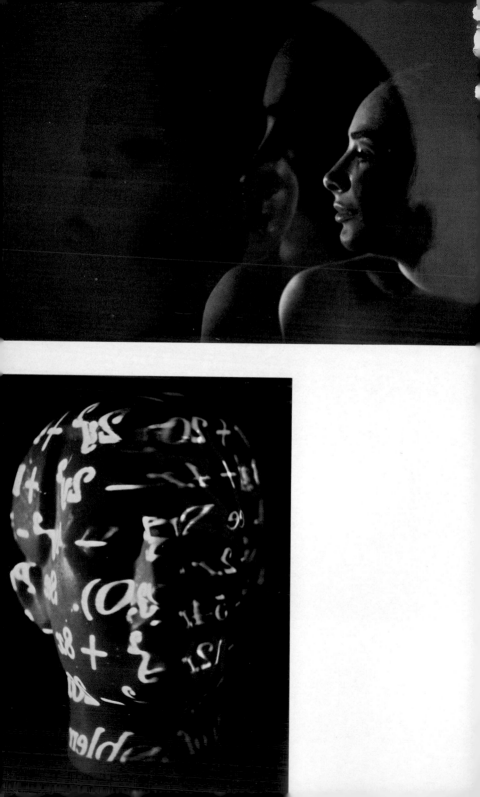

Plates 7, 8, and 9. The photograph on the top of the
facing page is a triple exposure. Each take was shot
with a different colored filter over the light source.
The photograph on the bottom of the facing page is a
color reproduction of the "head with math formulas"
shot discussed in Chapter 8. The photograph above is
a double exposure. The first take was a copy of a por-
trait (photographed through a flesh-colored filter),
and the second take was of the "abstraction maker."

Plate 10. This photograph is a double exposure of a woman's face and a reproduction of a painting. Some of the windows of the reproduction were cut out (and a light placed behind them) to produce the highlights.

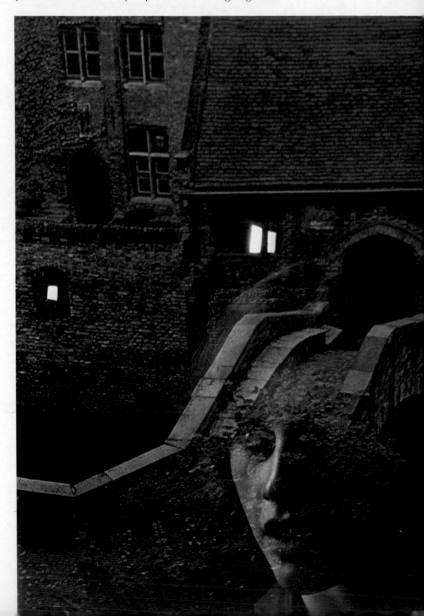

tins to a background; by varying the thickness of these tape balls, I formed a concave curve with the tins, like the inside of a bay window. When I had to do a color illustration representing a large crowd of revolutionaries, with elements derived from documentary photographs to simulate realism, I got three people into the studio and posed them with prop guns and menacing expressions. The six ferrotype tins, put together in a concave curve, multiplied these three people into a crowd of revolutionaries.

Use of Shiny Metal Objects

The reflective surfaces discussed earlier could reflect images in various degress of faithfulness, retaining some resemblance to the original image. But in the reflections picked up by shiny metal objects (unless these objects are fairly flat), the original image pattern is completely lost, and only the lights and the colors survive the trip around the bends, curves, and angles of the reflecting shapes. This reflection is a brand-new entity that can be permanently sustained only in a photograph. By using soft focus and placing these metal objects in a surrounding that alters their real dimensions and their original identity, you can transform, for example, kitchen utensils and auto accessories into supersonic vehicles and planets in the galaxy.

Making a Flying Saucer

I cut a circle of aluminum foil about 13 cm (5″) in diameter and scattered sequins on it, to simulate flashing lights. I placed it on a piece of black paper, about one third down from the top, and tilted the camera so that the aluminum disk would be elliptical. This was take I. I shot it in focus, out of focus, and at slow speeds from 1/15 sec. to 1 second. I wanted the effect of a disklike object moving at a high velocity through space.

When I finished shooting, I had a nagging feeling that the picture wasn't going to look right. So, without waiting to see the results, I decided to use another object. I bought a small aluminum funnel, the type usually found in the kitchen. I did not put sequins on it. I placed it on the same black background and spot as the previous object and shot it exactly the same way, with the same aperture

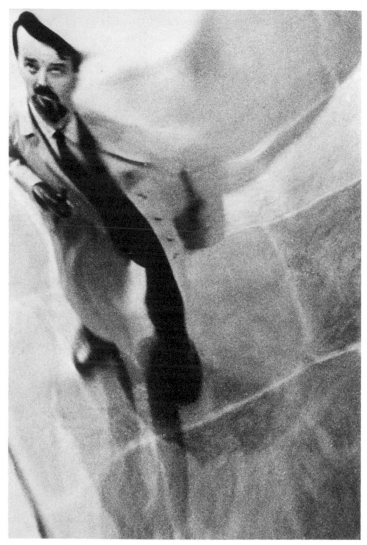

Fig. 4-17. This man was reflected in a metal sculpture
hanging from a museum ceiling. I had to be careful
not to appear in the photograph with him.

and speed settings. It was lighted from one side. (In this
take I, a dark blue instead of a black background could
have been used to reinforce the color of the sky in take II.)

I was very lucky: When I finished shooting the
aluminum funnel, it was the right time of the day for take
II. It was that fleeting time between day and night when

the sky is still a rich color, though it is getting dark, and some of the windows in tall buildings are lit. While photographing, I was very careful to make sure the tops of the buildings came up no higher than the middle of frame, so that the aluminum funnel, or "flying saucer," would be in the sky. I did some take II's of trees and sky. For these take II's, I went up and down in the exposures, varying both the aperture and the time settings, and I moved the camera during the slow speeds. The pictures were a success. I was correct in anticipating that the aluminum disk with the sequins would be wrong. It was no "flying saucer," it merely looked like a Christmas decoration hanging incongruously in the sky. However, the aluminum funnel was right. The three-dimensional shape caught the light correctly, and those takes with a slight movement in both the city and the funnel truly resembled a massive flying saucer racing across the sky above the city (Fig. 4-18).

Fig. 4-18 The flying saucer.

This is another example of how one can put unlikely things together with multiple takes, juggle their relative sizes, and produce a vast scene from the ordinary and the small.

Creating a Galaxy

In the section on mirrored setups, I mentioned using a glass sphere in a mirrored tent setup to create a feeling of timelessness. For another assignment, I decided to try to do something that would picture the traffic of futuristic vehicles moving through a galaxy in space. It is a challenge to try to create the impression of the vastness of the universe on a 35 mm color slide.

The items with which I decided to build this galaxy were a flattened pie pan, car side-view mirrors, and scattered pieces of aluminum foil to represent the moon, the space vehicles, and the stars.

For a long time I have been intrigued by the shapes of highly polished, cast stainless-steel auto accessories. The designers of these objects are artists: They come up with a tremendous variety of shapes without losing sight of the functions of the objects. As small parts of the cars, you hardly notice them; but separated and on display in a store they can be seen for what they really are. I have often gone into stores to admire these objects. Blown up to gargantuan sizes, they would look great in any show of modern metal sculpture.

Anyway, I finally had a reason to buy some, and so I purchased three side-view mirrors, one oval, one rectangular, and one round. I put them on a royal-blue background. Around them I scattered bits of crumpled aluminum foil in star-like shapes. The flattened pie pan, which would be the moon, was much larger than the objects, and I planned to include only part of it in the side of the frame. I varied my exposure and time settings. For some shots I held a prism in front of the lens, to break up the spectrum and put color on the highlights.

There are, of course, other uses for reflective surfaces; but, as they involve other techniques, they will be presented in the chapters where these other techniques are featured.

As I write this and recall and review my work, I remember, even feel, the excitement I felt so many times,

finding solutions to problems and first seeing results. I try to put myself in your place and predict what you will be doing as a result of reading this book. I'm sure it will be new and interesting and quite different from what I have done. I know that you will come up with ideas that I never thought of. I anticipate your excitement, your successes, and your frustrations. I sincerely hope that you will absorb as much information as possible, because everything in this book is based on experience. I hope that your successes will outweight your misses.

As you work, you will get more and more familiar with your tools and your materials. With them, and with the techniques and devices I have mentioned, you will be able to uncover the peculiarities, the characteristics, and the spirit of what you will be photographing.

5

Found Things

We have been inside the studio long enough, so let's take the camera and go outside. There is a rich treasure trove waiting for you—things you can capture and make your own with the camera. As you walk around, the camera heightens your sensitivities, and you become like a hunter stalking prey, looking up and down and all around, never knowing when you will discover the very thing you need or want.

When you go out, you might also take along a few devices: cellophane, a prism, a magnifying glass, or a black or plastic funnel, anything to help you externalize some inner concept and to manipulate whatever it is that you accidentaly find, or specifically seek.

Since this is the first time we are deliberately going outside, you should be aware that there are two main categories of color film pertinent to our work. One is balanced for shooting indoors with tungsten lighting and the other for shooting outdoors with natural lighting. Packed with each roll of film is a data sheet containing important information, such as ASA ratings, conversion filters, and so on. It is possible that, when double-exposing, you would do one take indoors and the other outdoors. Because of this, you should know about conversion filters in order to re-align the color balance, if you shoot with one roll of film in the two different light situations.

Daylight film used indoors with artificial lighting will have a reddish cast. Tungsten film, used indoors, will have a blueish cast. This is true of films from which you get

Fig. 5-1. Trees reflected in the surface of a pond.

color transparencies. But please, take the precaution of checking whatever film you may be using before photographing with it.

It is, of course, possible that you may want to exploit the quality of the incorrect color balance, in which case you would not use conversion filters.

How does one enumerate all the places in the world a photographer can work in? I'll limit this interminable list

to my favorite places. Besides making use of the obvious country and city scenery, I've haunted art galleries, museums, artist's studios, dance and theater rehearsal halls, junkyards, amusement parks, movie marquees at night. Wherever and whenever permitted, I have taken pictures. Following are some of the things I have found outside and photographed.

NEON LIGHTS

I especially like eye-level neon lights in store windows, because you can get as close to them as you wish. The light readings on neon lights are high, and here you might use the "two-finger" technique in front of the lens (see Chapter 3). You will discover as you look through the lens that the spread fingers, in addition to reducing the amount of light entering the lens, create an optical effect that changes the kind of design the neon lights create on the film. Be sure you shoot this out of focus, or at slow speed with a moving camera.

STAINLESS STEEL ON BUILDINGS

This material is used for store fronts, entranceways, and trimmings, especially on new buildings. A blatant neon sign reflected in a stainless-steel doorway was metamorphosed, and the doorway became a brilliantly colored abstract painting. For some reason, it reminded me of a giant butterfly. I went back to the doorway time and time again, making many different abstractions; I also used it for take II's on faces, silhouettes, and dancers. I was sad when the building was torn down and this combination of a sign reflected in a doorway one-half block away no longer existed. I once saw a brand new stainless-steel truck slowly move down a street, reflecting the store windows, signs, and people and becoming a glorious block-long, ever-changing abstract painting.

WINDOW DISPLAYS

Department stores and specialty shops often have very talented and imaginative people creating their window displays. I favor jewelry store windows. I have often stood in front of them with my camera, twisting and turn-

Fig. 5-2. The pigeon specter.

ing the focusing ring. You will gasp at the beauty of the
changes in the colors of the gems, especially diamonds,
when you look at them in this way through your view-
finder. Such window displays have given me many ideas
for new devices, new types of reflective materials, and
they've also suggested ingenious ways in which to use
them. Window designers understand how to use lighting
in many interesting ways. It can be quite a stimulating vis-
ual experience to walk on Fifth Avenue in New York City,
or any comparable street, and look through your camera.
A commonly seen but interesting shot can be taken by
photographing people who are looking at a window dis-
play; in the photograph they will appear reflected next to
what they are looking at.

When one prowls the streets with one's camera,
sometimes nothing happens and at other times totally un-
foreseen events take place. I was walking along a street
one day and happened to look up at a store window and
saw what seemed to be an apparition. I analyzed it and re-
alized that a pigeon had flown against the window and left
a mark of dust that resembled a fantasy bird. I quickly
went inside the store, and found that the sun was hitting

this dust mark so that it was brightly lighted. And to really finish off this string of lucky combinations, there happened to be a dark building behind the mark, setting it off with a contrasting background. A dust mark and all these circumstances created a new creature (Fig. 5-2).

USE OF MIRRORS OUTDOORS

I saw a mirrored sphere in the window of an optical store. It was a most remarkable solid piece of mirror. It allowed me to capture a part of the window, myself, the whole street behind me, and the sky, all in one photograph. Almost all stores and elevators have convex mirrors in them that give you remarkable views. I once saw a convex mirror on the side of a building outside a bank teller's window; it enabled the teller to see people coming down the street. It reminded me of a sideways periscope. In Glasgow, Scotland, you will see long narrow mirrors at right angles to every window in an office building. The purpose of these mirrors is to reflect light into the windows. I have found beautiful rose-tinted or purple mirrors in moviehouse entrances, some with gold veins in them in imitation of marble, out of which I made abstract take II's. I used one such mirror for a slide I did of the lighted tower of the Empire State Building at night, turning the night sky to purple and gold.

A friend of mine took a picture through the window of a luncheonette and, because of a mirrored post inside, but very close to, the window, got a photograph of what was in front of him and what was behind him: the people eating inside, the people in the street, and the buildings and the traffic behind him. It was as though he and the camera had vision in two directions.

GENERAL REFLECTIONS

At certain times of the day the sun's rays will bounce off windows and the metal trims and edges of buildings. In certain lights, the curved windshields of automobiles will show a bent and curved reflection of buildings and the sky, or an expanse of trees. If you're on a picnic and you've just finished your salad and the sun is high

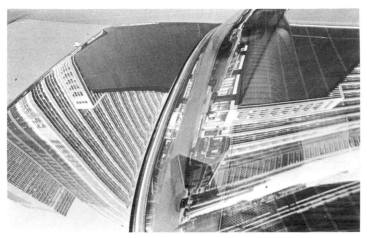

Fig. 5-3. It's amazing what reflections you can find once you start looking. This reflection was on the back window and trunk of an automobile parked on the street.

and bright, the sun's rays will bounce off the thin layer of the left-over salad dressing like a thousand sparkling lights, and it will seem as though you're holding a dish of a thousand tiny diamonds.

RAIN

Rain will do wonderful work for you. It will turn a dark forest into a place with a million little sparkling white lights as each little wet leaf catches a piece of the sky. Wet streets at night become wild abstract paintings, especially where there are many varicolored and bright lights. During the day puddles refract the sun's rays and turn them into piercing streaks of light, or you can find buildings, trees, the sky, and you reflected in them. Raindrops on automobile windshields become a multitude of small convex reflecting surfaces. They pick up the changing traffic lights, and as the car moves, these raindrops change from emeralds to rubies to yellow-and-white gems. Rain gives you a windshield that is a piece of patterned glass. During a rain, I have taken my camera, gotten into a cab, and had the driver go a few blocks just to take pictures through the

windshield. You should also observe what raindrops and rain do to the highly polished bodies of automobiles.

The American Craft Museum on West 53rd Street in New York City once had a participation show. People were asked to bring to the museum things they found in the streets—pieces of paper, boxes, bottles, and so on—or written impressions of what they saw, drawings, or photographs. On my way to the museum, I was looking all around, and as I turned the corner from Fifth Avenue into 53rd Street, I noticed that the sidewalk along St. Thomas's church was not concrete, but black slate; and a brief rain had changed the sidewalk into a shiny mirror. I found myself walking on a bright blue sky, on white clouds, and on trees; it almost pained me to take a step because I felt I was committing a desecration by putting my feet on the sky. I had probably walked on that particular sidewalk a thousand times and had never noticed its special quality before. But because of the challenge presented by the museum, my awareness level was way up.

This is the kind of "seeing" to develop for photography, and as you develop it you will begin to attain a mastery of technique. Coordination of penetrating seeing, or suprasight, and working swiftly, is important in every aspect of photography. The photojournalist or reportage photographer, who records things as they are, has to have this coordination. Even the photographer of formal portraits needs it, to capture that moment when the sitter is sending a vibration straight through the lens, past the film, right to the photographer.

And you also need this special coordination for this kind of photography, which is the converting of things from what they are to what you want them to be. You learn to work inside the limitations and, at the same time, stretch them. All this goes on while you are looking both around you and inside yourself to bring out that inner world, for you to see, yourself, and to show to others.

EXTERIOR CHRISTMAS DECORATIONS

In the business and shopping districts, you can find great decorations at Christmas time. I was particularly impressed by a very simple decoration of two Christmas

trees, side by side, reaching up to the fourth floor of an office building. They were simply two flagpoles with a series of poles coming out of the sides that gradually got smaller the closer they were to the top. Small white light bulbs, spaced eight inches apart, were placed on the center pole and on all the branches. It was simple and beautiful, and I shot a roll of it with a wide bracketing of aperture and time settings, in and out of focus, and with camera movement. One frame with slight movement was used for a cover of science-fiction book about projectiles. The clever thing the art director did with that shot was to use it horizontally. What had been a Christmas decoration in a vertical position became two projectiles moving through space.

GENERAL SCENERY

Combining a location and a person in a multiple exposure or a sandwich (Chapter 9) gives you the power to juggle and to alter their relative sizes. You can put a city on one side of a person's face, or put a huge eye in the sky.

The augmenting of the human being vis-à-vis his world is natural. I believe it is more real than the so-called reality of the snapshot of Mom and Dad dwarfed to insect size as they stand in the vastness of the Grand Canyon. Although that snapshot supposedly is what is, we and the people we know loom far larger in our minds than the great largeness of the world and the cosmos. Ask a flea, and it will tell you that it is the biggest being in its universe.

Michelangelo understood this when he painted the Sistine Chapel. He painted heaven, made the people in it so big, and put so many of them up there, that all one sees in his heaven are the people. Except for the fact that a lot of the people are partly naked, it's almost like the subway at rush hour. Not only knowing how we feel and think, but being human themselves, the early Renaissance painters made the people in their portraits big and put the scenery far back, so that a tree would be smaller than a person's ear. In art, all people demonstrate an awareness of the vastness of the universe; but the human dimension dominates, and we are compelled to reduce the measure of the totality of the world to our own dimensions. The vastness can only be implied.

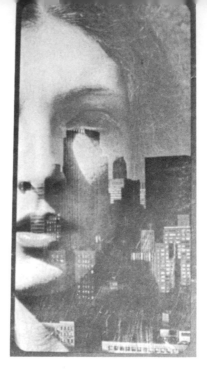

Fig. 5-4. A double exposure of a girl's face and a city skyline.

Face and Skyline

I photographed a girl outdoors in closeup, with light only on one side of her face, against a dark background in a sheltered area. This shot is usually hard to achieve in outdoor photography because the light is dispersed, so that you usually get flat lighting, backlighting, or strong top lighting with pockets of shadows around the features. Take II was the city skyline with a brilliant orange setting sun. Although I had not made a sketch or a diagram of take I, I composed the shot so that the sun came out on the underexposed side of the girl's face (Fig. 5-4). Otherwise, the sun and the bright side of her face would have canceled each other out. This color slide was used to advertise sleeping pills.

Exterior Mirrors

The chance discovery of a unique outdoor location was used to make a black-and-white portrait. I was photographing houses in the Beacon Hill section of Boston when I came across a mirrored entrance to an antiques shop. I

took a picture of a friend who was with me. She sat in a chair in front of the mirror, and I deliberately looked up at my own reflection and included myself in the photograph (Fig. 5-5). This is my favorite picture of myself. Most photographers, I think, are so used to being behind the camera that they get uneasy when they find themselves in front of it.

Country House With Figure

I used an old three-story gothic-style house in the country, silhouetted against a strong early-evening-blue sky. The eerie atmosphere of the house was accentuated by a single light in an upper window. That was take I. For take II, I photographed a girl in the studio with a filmy highlighted drape that fell from her head to the floor. She appeared to be running from the house (Fig. 5-6).

Fig. 5-5. A portrait of my friend—and a self-portrait.

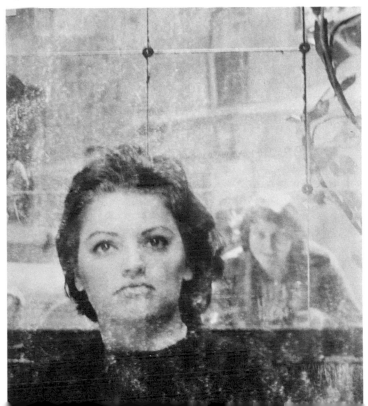

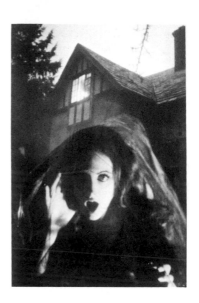

Fig. 5-6. A "ghost" running from an old gothic-style house.

General scenery. Often when I'm shooting outdoors and just doing general scenery I will put my finger in a corner of the lens, or off to one side, the way you use a "dodger" when printing black-and-white photographs in the darkroom. I do this if I want to ensure having a dark area on the film onto which I can add another image in a take II. If it is bright outside, it is advisable to wear a dull black glove when you do this, to prevent the light that can bounce off your skin from registering on the film. Be sure to press the depth-of-field preview button before you shoot. The size of the "dodged" area can vary according to the size of the aperture.

Again, these few examples are only a tiny portion of the possible ways to shoot general scenery. Needless to say, there is no end to what you can do. And even in this book, as we go on, there will be additional examples again and again.

PROPS

Now we come to the things that you find and bring back to the studio—things you would not ordinarily think of as being useful. But now perhaps you will look at them and see something in their shapes or in the materials they are composed of and begin to feel you can clothe them

with a new reality in one of your special put-together pictures.

The 5 & 10 was one of my favorite hunting grounds for things to spark my imagination. I had a special 5 & 10 I would go to and just wander around picking things up, holding them to the light, turning them around. After a while, the salesgirls realized I was neither insane nor a kleptomaniac, and one of them came over to me and said, "We got some new things in I think you'd be interested in." She was right; it was a gratifying moment.

In the sewing department I found sequins and beads. I bought all kinds of plastic sheeting—clear, frosted, and tinted—by the yard. The gift-wrapping department had gold, silver, and colored foil papers and sometimes colored cellophane. For rolls of colored cellophane, you may have to go to specialized gift and party-supply stores.

I bought Christmas-tree lights, sprinkles, embossed foil papers, shiny and varicolored Christmas balls. Small balls no larger than a fifty-cent piece were my favorites, and I used them for many abstracts. At Halloween time you will find masks and skeletons. I traced skeletons and skulls with a grease pencil on clear plastic sheets, which I hung like a curtain across the studio. Behind the plastic sheets I posed children dressed in white sheets and masks (Fig. 5-7).

I made forests and gardens from leaves and flowers bought in the artificial-flower department. Greenery arranged closely together, and sometimes put up against mirrors and photographed together with their reflections, made great jungles on several take II's.

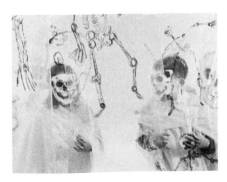

Fig. 5-7. A Halloween scene.

MASKS

There are stores, usually in amusement centers, that cater to the bizarre, the grotesque within us. They sell "horror" masks made of a skinlike latex material. They also have realistic masks made of a stiffer plastic. Some are flesh-colored and some are pure white; the latter are particularly strange. I have a theory that there's a whole area of man's psyche that is attracted to the concept of masks. The attraction seems to be a crystallization of a particular emotional state, the way a photograph can be one signifcant extrusion of a very convoluted, complicated human being.

A triple-take experiment. I decided to experiment with one of the "horror" masks. I mounted the mask in the center of a 41 × 51 cm (16″ x 20″) black board where I had cut out a hole. I glued and stapled the edges of the mask around the circumference of the hole. I placed this board in front of a light. I put a green scrim over the light behind the mask. I had already cut the mask eye-holes, to make them bigger. The green scrim showed through clearly in these holes, intensifying the frightening look of the whole thing. Take II was of crumpled foil paper, shot out of focus.

I repeated the same setup with a similar horror mask, omitting take II on the crumpled foil paper. Instead, take II and take III were repeat takes of the mask, with only two changes: I used different colors for the scrim on the light—take II was red and take III was yellow; I put the mask in a different position in the frame and for a few frames allowed takes II and III to overlap with take I. I also moved in and out to change the sizes of the masks, and I did some takes by shooting, not at a right angle, but from an oblique angle. Of course, I could have bought three masks and used three lights with three different colors on them and done it all in one take, but I'm sure it would not have had the mystery and effectiveness of doing it in three takes. By doing a triple-exposure you have more flexibility, and you also have the excitement of not knowing exactly what your results might be.

Another thing I did with the horror mask was to shoot it in a single take, filling up more of the frame area

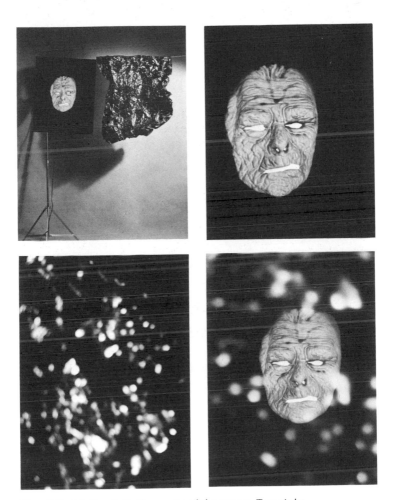

Figs. 5-8—11. Top left, the parts of the setup. Top right, take I—a close-up shot of the mask. Bottom left, take II the illuminated cellophane shot out of focus. Bottom right, the final double exposure—the mask appears to be floating in flames.

with it and using camera movement. Take II's on these single large shots were always simple abstracts on crumpled foil paper, for color. A favorite shot was made with a slight sideways swipe that gave the mask a happy, smiling look.

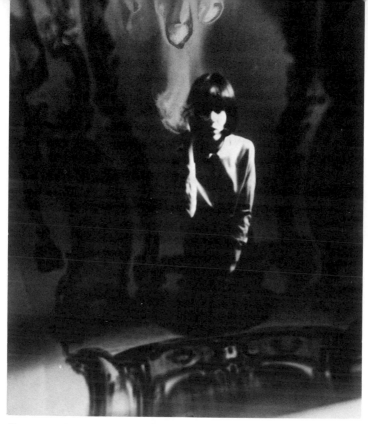

Fig. 5-12. This kneeling girl was photographed
through a large piece of clear plastic with a black
drawing of an ornate frame on it. It gives the impres-
sion that we are looking in on something very per-
sonal.

Other sources.

If you don't mind going out of your way, go to window-dis-
play houses; they have many things that might propel you
into various new experiments.

 I know that when you go outdoors you will find
props similar to mine and also many, many others. Al-
though we are all alike, and you may start out doing the
same things I have done (even following some of my ex-
plantations step-by-step), ultimately what you achieve
will be different. After all, we all exist in our own individ-
ual time-and-place slot. I can assure you that you will have
the thrill of creating some very original and beautiful
slides.

6

Silhouettes

A silhouette photograph, either black-and white or color, has light on the background only. The subject has no light on it at all and is completely underexposed, or black. Since no light falls inside the shape, all the detail is lost. Whether you shoot an object or a person's head, or head and shoulders, or full figure, the shape is all that you have to identify the subject. A silhouette has a flat, two-dimensional feeling, since none of the details that normally sustain the impression of three-dimensionality are visible.

Silhouetting is particularly useful and interesting when you are working with multiple exposures. It is the reverse of all the work explained so far, where the unexposed film was the area *around* the subject and it was in those unexposed, or underexposed, spaces where you planned to place your subsequent takes. In silhouetting, it is the subject itself that is unexposed (or sometimes underexposed), and so, conversely, you plan your subsequent takes to fall *inside* that shape. In the true silhouette, the background has been overexposed and nothing will record on it, but this can be varied. There are some cases where the background does partly show and does record some of take II.

When you take exposure readings, make sure the silhouetted area has no reading. You must always be sure you expose only for the background, so that the subject is underexposed. If you do not wish the background to be completely washed out (overexposed) and hope to pick up

85

Fig. 6-1. Silhouette with a hot spot.

something of take II in it, here are some precautions to take:

1. The head, figure, or object can have edge lighting to give it an outline and thus separate it from the background, which is not totally overexposed. In the chapter on sandwiching there will be an example of an edge-lighted silhouette.

2. The other way of creating a silhouette with some underexposed area in the background is to have only part of the background totally overexposed, such as a hot spot behind the figure. In this case, you must make sure that the hot spot is large enough for silhouetted shape to be recognizable (Fig. 6-1).

A silhouette of a head in profile, or a front view, or a three-quarter view of a head and shoulders are easily identifiable (Fig. 6-2). However, should the model be wearing a coat with a hood, or have long thick hair, you can readily envision that it would be difficult to identify a front-view silhouette. Or, if the model's arms were up over the top of the head (a gesture children often make) you can again envision that, in a silhouette, one would never know who or what the subject was. I should also like to point out that if you are using two heads or two figures, carefully study the parts that overlap and be sure that the resulting composite shape is recognizable (Fig. 63-A). If you are not careful,

Fig. 6-2. A profile silhouette.

you might end up with two heads on one body, or one head on a broad body with three arms (Fig. 6-3B). This could be interesting to explore, like the shadow figures that people make with their hands to entertain children. However, I'm sure you wouldn't be too happy if you wanted a silhouette of a boy and a girl with a pigtail and ended up with the silhouette of an elephant.

Figs. 6-3A and B. Right, a silhouette with two people, recognizable as two people. Below, another silhouette of two people—funny, perhaps, but generally not as useful as the example on the right.

Indoor Methods. Making silhouettes indoors is easier than making them outdoors, since indoors you are in control of the lighting. If you decide you do not want a totally washed-out background, you can have a color for the background, or a design. In Chapter 8, which deals with back projection, you will discover that using your slide projector for back projection is a foolproof way of making silhouettes with designed and colored backgrounds.

If you expect to do take II out of doors in daylight, use outdoor film, even though you are shooting the silhouette indoors. The color balance of the film is of minor importance in take I, the silhouette; so the choice of film should be based on what take II will be.

The bracketing of exposures does not have to be broad. Once you establish that the exposure reading, and thus the amount of light on the silhouetted area is sufficiently less than the reading on the background, a bracketing of one stop over and one stop under the reading is all that is necessary. This gives you a five-stop spread: one stop under the reading, one stop on, one stop over, and the two half-stops in between. The important records to keep in shooting silhouettes are careful sketches and diagrams of the compositions, to guide you so that you place take II precisely in the area of the silhouette, since it is only there that take II will register (except in a not totally washed-out background, where it will register partially).

Keeping Records. Let us assume that you are ready to start shooting silhouettes. You might try shooting a person in a close-up profile, then try medium and long shots. Be sure to make diagrams of everything. For take II's there are several things to do. Start off with abstracts. Even if they spill over the periphery of the silhouette, it doesn't matter too much. General scenery is also very good to combine with silhouettes. Just be careful when you expose take II's with scenery: It is very easy to overexpose and completely lose the shape of the silhouette.

When shooting take II's, consult your take I diagrams and make sure that the main areas of take II fall on the silhouetted areas. There is no end to what you can put inside a silhouette, from a single flower to a whole garden. You could do crowds of people, or one other person, fully lighted. You could do traffic, or a view of the city from the

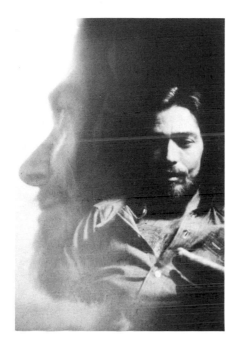

Fig. 6-4. A man inside his own slightly silhouetted profile.

top of a skyscraper. If you wish to shoot at night, do theater marquees, the streams of automobile lights on a highway, or scenes in a theater, ballet, or opera. I have even used pictures shot off a TV or a movie screen. I have also put a portrait of a person inside his own silhouetted profile (Fig. 6-4).

Some Projects Explained

- In Barbados, on the silhouetted take I profile of a Barbadian, take II was an overall scenic of the beach, palm trees, ocean, and sky.
- I did a night city scene of lighted windows and traffic on the silhouetted figure of a young man.
- You might try to do a sports event, although I never have. For instance, you can make a silhouette of a football, tennis, or baseball player, and then use the overall view of the actual game as a take II.
- You might do the silhouette of a child, and then a symbolic shot from the child's life.

Can you see how all of these combinations of elements can explode into a multiplicty of effects?

Here are some explanations of silhouettes I have done:

1. I photographed a teen-age boy holding a guitar (a good shape for a silhouette) against a not totally washed-out background. I went outside looking for a likely take II and found a neon sign that had a series of red lines, which I used. These red lines suggested the lines of the music staff, and I felt they were related to the guitar. The red lines covered the whole frame; they were powerful in the silhouette area and faded where they crossed the somewhat washed-out background.

2. The slide explained in No. 1 was only half of a roll of film. The other half of the roll had the boy's silhouetted profile, with his head tilted back. I decided to find another take II for that. A few days after I photographed the profile, I had to go to the studio of Pat Sloane, the artist, to photograph her paintings. I took this roll with me. I had taken it out of the camera, taking care to be sure that the leader remained outside the cassette, as explained in Chapter 1. I knew which was the last frame of the boy and the guitar, and where the silhouetted profile started, awaiting a take II. When I finished the job of photographing the artist's work, I reinstated my exposed roll in the camera, lining up the lines drawn on the beginning of the film, as described in Chapter 1. With the lens covered, I moved the film forward to frame No. 11, where the silhouetted profile started.

I was going to use a detail from one of Ms. Sloane's paintings for take II. I decided that a heavily outlined cartoon-like profile in vibrant colors would be the take II. Using a diagram to help me, I carefully placed one of the profiles in her painting inside the silhouetted profile. The painted profile, like the photographed one, was also tilted up. It worked extremely well (Fig. 6-5). This slide, plus the one of the guitar, the boy, and the red lines (along with three others to be explained in upcoming chapters), were used to illustrate an article on "Fantasy Photography" in a magazine. That's pretty good going—two published pictures on one roll of film.

3. I photographed the silhouetted profile of a girl singing. I wandered about the streets looking for a likely take II. I was seeking something that would visually emphasize the quality of singing. What I found was a red,

Fig. 6-5. A painting inside a silhouetted profile.

white, and blue neon sign in the window of a shoe-repair shop. The sign was at eye level, so I could get as close to it as I wished. Many good things are the wrong distance or the wrong height, and it's frustrating to have to let them go.

I decided to shoot at a slow speed, but this necessitated closing the lens down to f/16, which is the smallest aperture on my lens. According to my exposure reading I would have to shoot at 1/8 sec., and I wanted to shoot at least at one second or more. In desperation, I put two spread fingers over the lens, as though to squeeze it. Although I already mentioned this "device," this was actually the first time I used it. I had concluded, not so logically, but correctly, that it would cut down the aperture. I find it interesting that intense need, rather than clever thinking, often solves problems. Besides cutting down the aperture, the "device" also changes the form of what you're shooting, over and above the changes made by the moving of the camera. Optically it must have something to do with the shape of the fingers, as the light comes around them. I have also taken a pipe cleaner, bent it around in a spiral, and held it against the lens; it, too, distorts and changes the way the image gets recorded on the film.

Well, anyway, what came out for my take II was not a red, white, and blue shoe-repair-shop neon sign at all, but wavy, delicate, flowy lines that gave an impression of

Fig. 6-6. A traffic sign on a silhouetted profile.

sound waves, as though the sound of her singing had been caught and recorded visually.

With this same "singing" profile, I did a take II on a DON'T WALK traffic sign. I liked the slide and decided to do another one using the same sign. I did a similar profile with another girl who wasn't totally silhouetted, so some details of her features showed. When I reshot the DON'T WALK for a take II on the new profile, I did several frames with what I call a syncopated movement, where I hold still for part of the exposure and then make a whiplash sweeping movement for the balance of the exposure. The result was lettering which was legible, but which had streaks behind it like the music lines of the staff, giving the transparency a feeling of sound (Fig. 6-6). This picture was used as a record-album cover, coincidentally entitled, "Don't Walk."

4. There have been several times when I photographed silhouettes on "prepared" rolls because I was confronted with an interesting shape, and then put the film away with notes and diagrams until a likely take II came along. Here are two examples:

a. A friend came to the studio wearing a conventional dark brimmed hat and a heavy dark winter over-

coat. He made a great shape. I asked him to make threatening gestures and photographed him silhouetted against a white background. It was several weeks later that the right-looking model came to the studio, wide-eyed and defenseless looking, and I felt she would be a good take II. Carefully following the diagrams, I placed the model so that she would be completely surrounded by the silhouette, and I directed her to look fearful for some frames, and innocent and unaware for others.

b. Another shape that presented itself to me as a good silhouette was a young man with a very muscular build. With him I did not do a total silhouette; I picked up a little detail inside the shape to show some indication of his physique. I only did one simple, straightforward pose, hands on hips. I used a broader range of bracketing than I normally do for silhouetting, so that I would have a range from total blackness in the figure to what I call a semi silhouette.

I put this "prepared" roll away (in the refrigerator) with notes and a diagram until several months later, when I was shooting a young woman. I used her for a take II on this roll, framed within the area of the silhouette. One of the transparencies of the semisilhouette of this set was used as a paperback book cover.

Another shape that lends itself to an effective silhouette is a hand; I have used it several times. Take II's have been abstracts, a face, a whole person, scenery, and a flower.

5. Now we come to an example of a silhouette with a hot spot behind most of the figure. The background has an area partly white and washed out, surrounded by an area as dark as the silhouette (see Fig. 6-1). I had a very strong circle of light behind the body and part of the arms and legs of a male dancer. He was in a lunging position, head thrown back, and arms spread out. His hands and feet disappeared into the darkness of the background around the hot spot. Since this was an assignment with a specific theme, my take II had to simulate a fiery atmosphere. The shot was to be used for a cover of a science-fiction book about people who lived in an environment of flames. Take II, which would be picked up on the silhouetted area of the film, i.e., the man's body, and on the background around the hot spot, had to be that fiery environment of the planet.

I thought I would try three different types of flames. For the first set of take II's I used a whole box of small birthday candles. I set them very closely together in an earth-filled black developing tray.

For the second set of flames I used the flames in a fireplace, also with a wide bracketing.

For the third set of flames, I crumpled up some bright red foil wrapping paper and illuminated it from the side, for highlights. I shot this setup two ways: out of focus, and on a slow time setting with a little camera movement.

When I got my results, I saw that my idea of using a silhouette with the hands and feet seemingly pinned to the dark area of the background around the hot spot worked well. The flames appeared on the body and on the background shadow. The birthday candles were obviously little spots of fire; the flames from the fireplace, on the other hand, were too mushy; the last set, with the crumpled gift-wrapping paper, was the best. This is another example of how in photography the real thing may not be as good as the "fake" thing.

I don't know what it is that brings the right elements together. Some call it luck. But it also has to do with striving, working hard, and really wanting something to happen.

As I have said earlier of previous topics, the subject of silhouettes will come up again, but as they are combined with other special effects, such as reflective surfaces, camera motion, found things, and general scenery, I will talk about them in the chapters where the other techniques are discussed.

7

Using Black-and-White Photographs

Having been a photographer for so many years, I have a large file of black-and-white photographs, including many portraits. Sometimes, when faced with a problem in multiple exposures on color film, I have realized that a certain black-and-white portrait would be a perfect soluton for that particular problem, and I have tried to think of ways of recreating the portrait with color film. Suddenly the thought came to me: Why should I try to re-create the existing photograph, when I might be able to copy it? And so I developed a method for copying an existing black-and-white photograph on color film: I use color filters on the lens to restore flesh tones to the picture. I might also double-expose with a chrome surface or an abstract to fill the shadow and dark areas with color.

Around the time I was experimenting with this technique I bought a star filter. A light facing the lens with this attachment on it will have its rays split into crossbeams. With one star filter on the lens, you get four beams radiating from a central point. But you can put one star filter on top of the other, and so get eight beams.

Very often, I develop a new technique when I have some free time and want to start on something. Or I get an image or thought in my head that I feel I must express, and I just start putting things together. You will probably find yourself doing the same thing. In this case, I bought the star filter just about the time I started working out the problem of using black-and-white photographs, and the two things complemented each other. I'll show you how.

A PORTRAIT MONTAGE

I realized that the best portraits to work with (although I used other black-and-white photographs besides portraits) were those with a black background. The first portrait I worked with did not have a black background, however. Taken in the street, it was a photograph of a man with an intense expression. I had experimented with it in the darkroom, making many prints with different croppings. I cut the head out of six of the prints and blackened the cut edges with a felt-tip pen. I pasted these heads in a group on the bottom half of a large sheet of black paper (see Fig. 7-1). I then hung the sheet from the horizontal bar of the light stand.

Simultaneously, I decided to try out my new star filter. Realizing it worked best with light coming directly into the lens, I punched holes in the pupils of all the eyes of the six portraits. I placed a light behind the black paper, and beams of light came through the holes in the eyes. Of course, I also lighted the front of the montage, since I wanted the faces to be seen. I knew that I'd have to be careful to keep the front light from overpowering the beams of light coming through the eyes, and so I looked through the viewfinder to see if I could see the beams. I could. Cross-beams of light were coming through every eye, though some eyes showed more beams than others. In order to measure the difference in the light between the beams and the front lighting, I turned off the front light and took a reading on the beams. Then I turned off the back light, which created the beams, and took a reading on the front light. The beams were two stops brighter. If there hadn't been that much of a spread, I would have had to make an adjustment by moving the front light closer or farther away. There is no such latitude with the back light, which must be as close as possible to the holes in the eyes. I then set up a frame-number and exposure chart, based only on the front-light reading. I decided to ignore the reading on the beams, once the two-stops spread was established. I also felt that wide exposure bracketing would be necessary, since this was the first time I was working with the star filter and black-and-white prints. I also used a flesh-colored filter on the lens, though I had no idea how well it would work with the star filter. But it worked well.

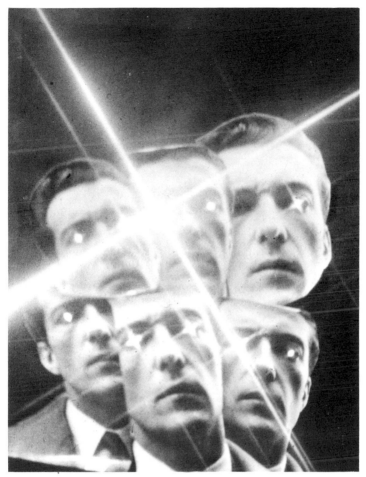

Fig. 7-1. The "portraits-and-crossbeams" montage.

Charting the Test

With only the front light on, the reading was f/4 at 1/30 sec. The reading on the beams was f/8 at 1/30 sec. I shot a few frames slightly out of focus. What was interesting in the exposures was that the beams, being so thin at f/8, were swallowed up by the surrounding darkness, and all that showed in the eyes were white holes just starting to become crossbeams; but at f/2.8 the beams were clear (see notes on chart and Fig. 7-1). For take II, I used some pieces of red, blue, green, and yellow paper and shot out of focus,

with some camera movement. I avoided any highlights that might have interfered with the beams, since the beams were the main theme of this project. Take II warmed up the black areas and the shadow areas of take I. There were many good slides on this roll, but I preferred the darker ones.

DEMONSTRATION EXPOSURE CHART FOR
PORTRAITS-AND-CROSSBEAMS SHOT

Frame #	Exposures		Results
1	f/1.4	1/30 sec.	everything is too light
2	f/1.4–2	"	
3	f/2	"	fair
4	f/2–2.8	"	
5	f/2.8	"	excellent
6	f/2.8–4	"	
7	f/4		beams good—faces slightly dark
8	f/4–5.6	"	
9	f/5.6	"	beams good—faces dark
10	f/5.6–8	"	
11	f/8	"	no beams—square spots for eyes
12	f/8–11	"	almost no faces

No one realized that the faces were taken from a black-and-white photograph. The beams of light came through brightly, and the overall impression was intriguing; the picture aroused the viewers' curiosity. Everyone, including very experienced photographers, asked me how it was made. No one could figure it out. The transparency was used for a cover for a book about spirits; and because the main part of the composition occupied the bottom half of the slide, there was plenty of room on the top for the title.

B&W PLUS COLOR PRINT

Several years earlier I had had a magazine assignment to photograph in Arizona. During that time I made a portrait, which I still had, of a Native American against a black background. I also had a color print I had made of a desert scent, with cactus in the foreground and a brilliant sunset sky. I took these two pictures, the black-and-white

print and the color print, and put them together with a double exposure for the cover of a book about ghost stories of the Old West.

Take I was the desert scene: I photographed the existing color print, using a wide exposure bracketing. I don't know if it is necessary, but I would like to explain again why wider exposure bracketing is needed for multiple exposures than is needed for single-take pictures. In this particular case I was working with an area (the sky) that was not black, but brilliant orange; the second image was going to be placed in this area. I knew I was going to lose some of this brilliant orange color but wanted to maintain an indication of it. With a wide bracketing, you stretch the range wherein the highlights of the second image can be stronger than the tonalities of the first and the colors of the first take can fill up the shadow areas of the second take. A wide bracketing is like gambling with all the odds covered.

Take II was the portrait of the Native American. I used a black mask in front of the lens. This was just a piece of black paper with a hole in the center; I moved it back and forth in front of the lens so that only the head in the portrait would come through and register on the film. I placed the head very carefully in the frame, in the area of the sky of the first take. This head was large, and it filled up

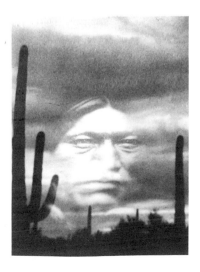

Fig. 7-2. The Native American spirit in the desert sky.

a big area of the sky (Fig. 7-2). There was also a flesh-colored piece of cellophane on the lens to give the black-and-white picture a flesh tone. With this take, a wide bracketing exposure was also used. I had to contend with the fact that the black mask reduced the exposure reading.

THREE B&W'S AND A STAR

Besides using the black-and-white photographs that I already had, I also took some black-and-white photographs specifically for the purpose of making color slides from them. Essentially, I did this because I liked the particular effect I got with color slides made from black-and-white, and also because sometimes I wanted to work with prints, and black-and-white prints are easy to work with. For example, I got an assignment to do a color slide illustrating witchcraft. Here are the reasons I photographed the model in black-and-white before copying onto color film:

1. I wanted to use the star filter to get light beams coming out of the model's eyes, and obviously you can't do that with a live model or a color transparency.

2. I had an existing black-and-white photograph of a cat's head staring straight ahead that I wanted to use for this illustration, and I wanted light beams in the cat's eyes, too. I also decided to include a black-and-white photo of an owl.

3. There would be a need to change the relative head sizes of the cat and the model, and this could be done easily in the darkroom if I was working with prints.

4. There was a layout to follow with the heads in specific positions. This would be impossible "live," but possible with black-and-white prints.

I mounted the three prints on the black paper in their designated positions, hung black gauze in front of the montage, and cut holes in the gauze in front of the heads. The gauze was forward enough to be out of focus, and it helped disguise the fact that the heads were just three black-and-white prints mounted on the black board. (The gauze would also enable me to leave some of the frames on the roll without a take II, because it would cut out the background and add its own unusual effect to the pictures.) While shooting the setup, I referred to the "six-

head" exposure chart earlier in this chapter. I adjusted the lights, both front and back, until the readings for the witch, the owl, and the cat matched the "six-head" exposure readings. I then followed the chart.

For take II, which was exposed on every other frame, I decided that I wanted streaky circular lines. I attached small multicolored Christmas-tree bulbs all over the black paper, except where the heads were, with black masking tape, and then I covered the heads with black paper. (These lights were on dark green wires, which become totally underexposed when the bulbs are lighted.) Take II was shot at $f/16$ at 1 second and ½ second; I shook the camera and also made circles with it during the exposures. The results were satisfactory.

ALTERED B&W PRINTS

A photograph you take casually can set off a train of ideas, and you might find you end up with something apparently unrelated to the original photograph. Here is an instance of one such thing that happened to me. A friend and I had worked on a project, and we were studying the slides on the slide sorter. When we were done, we put the slides away and started discussing what we had accomplished. However, we forgot to turn off the light on the slide sorter. That produced wonderful lighting on my friend's face; so I picked up my camera and quickly took some black-and-white pictures of him while he was talking.

I decided to make an enlargement of one picture of him with his mouth open and his eyes cast up. In that shot he looks quite happy, positive, and animated. With all the manipulations I performed, the transformation of the black-and-white portrait to color changed the whole emotional content of the portrait. In the finished color transparency my friend is in a state of fear, terror, and agony.

To achieve this transformation, I made an 11" x 14" black-and-white print (Fig. 7-3A), trimmed off the borders, and mounted it in the center of a large piece of black paper. I cut out the area inside the lips and put holes in the eyes (Fig. 7-3B). I stuffed the mouth with crumpled red cellophane. I used the same lighting I used for the previously described project on the witch and the cat. I put a piece of

Fig. 7-3A. A straightforward black-and-white print.

Fig. 7-3B. The same print with the eyes and mouth cut out.

pink cellophane in front of the lens to restore flesh tones in the highlights of the face. The light used behind the eyes for the star filter spilled over and turned the red cellophane into something that looked like flames. There appeared to be a fire inside my friend, and he seemed to be screaming in agony. Take II was some simple out-of-focus spots of color to fill up the black background.

OTHER SUBJECTS

Here are some examples of subject matter other than portraits that I transposed from black-and-white to color:

1. I took a black-and-white print of an airplane resting in a field, cut out a hole in the nose of the plane, and placed a light behind it. I then photographed the print with a star filter and an orangish piece of cellophane on my lens. With the star filter, the light coming through the nose of the plane looked like a hot spot from the sun. Then, with the plane in the center of the vertical frame, I put a take II of two people in a lunging position below the plane. They seemed to be running forward from the plane; and the shot became the cover for a spy book set in a desert locale.

2. I took a 300-year-old medical drawing of a skeleton and its muscle structure, and after I made a reverse black-and-white print it became a white drawing on a

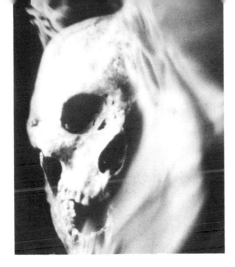

Fig. 7-4. A skeleton
dancing around a skull.

black background. This, reflected in polystyrene, I double-exposed around a closeup of a skull. The polystyrene gave the skeleton a wavy undulating appearance, so that it seemed to be dancing around the skull.

3. I put blue cellophane halfway between the camera and a black-and-white print of a Scottish castle in the evening mist. I cut a square hole in a window in a tower, put a light behind it, used a star filter to get crossbeams, and photographed this as a take I. For take II, I photographed a model in the studio, placing her in the bottom half of the frame, and so she appeared to be running away from the castle.

There are many more possibilities to develop in this area of transferring black-and-white photographs to color. For instance, I'm sure there is an imaginative way to use old snapshots, historic pictures, memorabilia, etchings, technical drawings, graphic designs, or even newspaper print, anything that is not under copyright protection. You could also get a time-out-of-kilter thing going, overlapping pictures of a person at different stages of life. The camera can photograph only what is, but we can add certain materials and use the camera to break out of our own time box, fly around in time, and mix time up, the way we do inside our minds and in our fantasies. This makes me think of Aristotle's statement, "A work of art should imitate the movements of the mind, and not an ordering of facts."

103

8

Using a Projector

I love this work because there are always surprises. You never know what can present itself for you to use as a device. You look around at all the familiar things, and suddenly it is as though these things are reborn. They become something else. You use them for something they were not designed for, and they become tools through which you express your thoughts and ideas. That is what happened with my slide projector. I used it to project on "wrong" surfaces, rephotographed the projected image, and this synthesis, in turn, became a new image.

Here are some of the "wrong" surfaces I used:

1. A white plastic copy of a classic head, bought in an art-supply store.

2. Human bodies.

3. The back of a translucent plastic sheet, which in turn became the background for a silhouetted figure.

4. Ferrotype tins, polished mirrorlike stainless steel sheets.

WHITE PLASTIC HEAD

A transparency of the white plastic head with numbers projected on it was used for a lead editorial page in a magazine to symbolize the place of advanced mathematics and computers in the financial world. The head was put on a table covered by a black cloth, in front of a black background. The image projected on the head bent and slipped around the contours of the head.

If you think of it in reverse, the bends of the projected image define the shape of the head, or of any other three-dimensional form you might be using.

How it was done. The art director and I decided to copy math equations and graphs and project them on the head. With a close-up attachment on the lens, and using high-contrast black-and-white film, I photographed the formulas and graphs in an advanced-mathematics book, varying the exposures to make sure of getting negatives with good density in the white areas and clarity in the numbers and lines. Camera distance was varied, to get different amounts of material on each slide. These black-and-white negatives were then cut up into single frames and, together with colored pieces of gelatin, put into transparency mounts. The colors used were red, green, blue, yellow, orange, and purple. I got open mounts from the color-processing lab. Instructions for inserting and sealing these are in Chapter 9. You can also buy empty mounts in a photo-supply store.

I made at least 20 slides, so that I would have a good selection to pick from once I started projecting. I hope you realize that each mount held two pieces of transparent material, a black-and-white negative and a colored gelatin. In effect these were sandwiches, which will be dealt with in Chapter 9.

Now comes the tricky part. The white plastic head was set up on a table, sufficiently far from the background so that any "spill" from the projected slide would fall into empty space, not on the background. For this project I used three projectors. With three projectors you can cover the whole face—one projector for the front of the face and one for each side. Three slides, each a different color and a different formula, were projected simultaneously. Besides the formulas, I also shot some pictures using three projected slides of the graphs, each with a different color.

This project took time and patience. The head had to be moved around, different slides had to be tried, the projectors had to be moved back and forth, tilted, and angled. We had to decide how to overlap some of the projections. You could do this alone, but it's easier if you get someone to help you. There are so many variables, and with each change you have to run back to the camera,

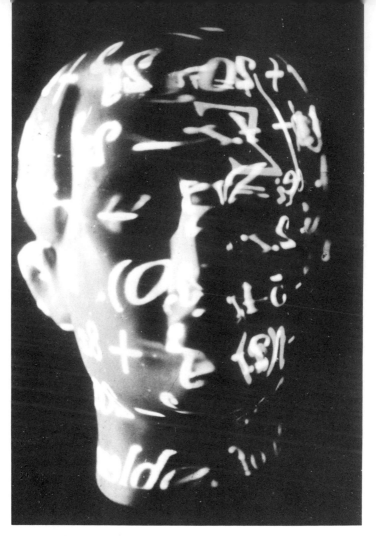

Fig. 8-1. Math formulas projected on a plastic head by three slide projectors.

study the new effect through the viewfinder, and decide what to try next, until you feel what you have is right.

The only source of light is the projected slides; so getting exposure readings can be difficult. Take your time, be careful measuring the light, and be prepared to have a wide exposure bracketing.

I wanted as much sharpness as possible and plenty of depth of field, so $f/8$ was to be the largest aperture. A

tripod had to be used. Since this was a still life, the exposure-bracketing spread would be accomplished mainly by varying the time settings, with some variation of the aperture. You must plot your exposure chart before you start shooting and then follow it as you shoot. My reading was $f/$ 11 at 1/4 sec. For my first three sets I used variations of the math formulas. (Fig. 8-1). For my fourth set I used the graphs; and the way the straight lines of the graphs bent, curved, and wrapped themselves around the head without losing their identity was quite beautiful.

The transparency of the head with the varicolored math formulas was used in the financial magazine. The head with the graphs was used as a cover for a science-fiction book. On the basis of these printed pictures I got an assignment to do something similar for an interior-design magazine, with room-setting plans projected on the head.

There are many other things you can do with this basic setup. For projected slides you could use line drawings, etchings, movie signs, posters, advertisements, stock-market quotations, or symbols. Just let your imagination go, and then perhaps make up a whole variety of slides from black-and-white negatives and color gels and have them ready to try out interesting projects. If you use color film to make copy slides from the negatives, you will have projections that will be positive, or identical to the material originally copied by the black-and-white film.

HUMAN BODIES

I used human bodies as projection screens, projecting an abstract design on two dancers in white tights and leotards. They held their poses for me, and I hand-held the camera and shot at a wide-open aperture. (Figs. 8-2A and 8-2B.)

BACK PROJECTION

You can make your own back-projection screen and do some wonderful work with it. Finding frosted colorless plastic sheeting can be difficult, so what I did was to get several sheets of nearly clear plastic and hang them from a line I strung across the studio. They formed a sheet that

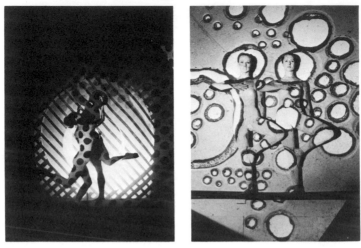

Figs. 8-2A and B. Two examples of human bodies used
as projection screens.

was 0.9 m wide by 1.27 m long (36″ × 50″). That is large
enough to allow a medium shot of a person standing at
least one foot in front of the sheet (Fig. 8-3). Since you'll
have the projector on one side of the sheet and you and
model on the other side, you need a long area to work in.
(With a 35 mm lens on my camera, I worked in area 610
mm (24′) long.) What you are doing is creating a silhouette.
I have always used a "screen" that hangs flat, but you

Fig. 8-3. The setup for back projection.

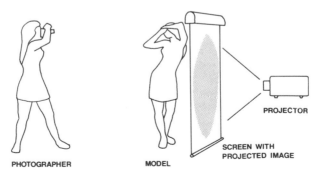

PHOTOGRAPHER MODEL SCREEN WITH
 PROJECTED IMAGE
 PROJECTOR

could get some interesting results if you draped your sheet with folds, like a curtain, or if you pushed something against it so that it would bulge, or pulled it at some point with a fishhook on a nylon line. In this kind of photography anything goes—if it works. The person you get to pose in front of the screen should be relaxed and be able to move well. It would be good to get a dancer or a child. This project is like a game of "Statues" you played as a child. The model will have to make poses and hold them. It is a good idea to have the model face the screen and react to the image on the screen, as though the model and the image were partners doing a dance. Also, remember that profile views work well (Fig. 8-4).

And what would you project on the screen? Anything—abstractions, a portrait, a crowd, a country scene, a still life, an animal, a city street, and so on. Remember, your sole source of illumination is the light from the projection, so be careful of your exposures.

I projected a predominantly red abstract slide and my model, facing the screen, posed with both arms up. The brilliant swirling colors of the projected abstract slide came out on the transparency. The model was a complete silhouette, but the pose was so simple that its meaning came directly across. The slide was used for a cover of a book about voodoo.

Fig. 8-4. Profile of a girl with back projection of a face.

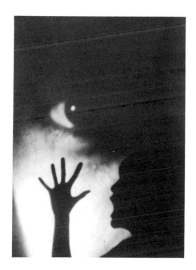

Multiple exposures could also be used with back-projection work. Since the exposure settings are based solely on the light of the projected image, the model is totally underexposed; in fact, the model is a black silhouette. So, if you made a careful diagram of the model, you could then do a take II inside the silhouetted shape.

FERROTYPE TINS AS PROJECTION SCREENS

I had some transparencies on file that I had made for myself after I had completed an assignment using a male dancer for a model. I had admired his movements so much that I decided to shoot a roll of him just dancing as he wanted to. He was barefoot and wearing practice clothes, black tights and a sleeveless orange top. The lighting on him was subdued, and the background was a white wall. One of the movements he made was to rise up on his toes, stretch his body upwards, and start lifting his arms slowly like a bird getting ready to fly away. It was a simple movement, but very beautiful, and I photographed the arm-movement sequence in its various stages.

About a year later, when I was going over my slide file, I became entranced with this series of slides and decided to project them. I enjoyed seeing the feeling of flight they conveyed, and admired the fact that this earthbound man, a dancer, could so capture the essence of the movement of another species. I thought that I, by my work as a photographer, would try to release him from his earthboundedness and really let him fly. I would try to bring about through the techniques of photography the completion of the movement he started.

Motivated by this thought, I started tilting the projector. I had a great time projecting all over the studio, up on the ceiling, into corners, sideways, down on the floor, on curved white background paper; stretching the dancer to carry forward his movement beyond what he could do; elongating his body and legs, till his feet seemed to leave the ground. But I still felt something was missing. I thought I'd try projecting on something other than the wall.

I got a ferrotype tin to use for a projection screen; it was not an intellectual decision but a sudden inspiration, an almost reflex action of dimly knowing and reaching for

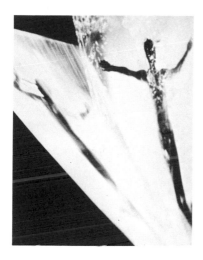

Fig. 8-5. Take I and take II of a
dance photograph projected
on a ferrotype tin.

what I felt was needed. I propped this 10″ × 14″ mirrorlike
piece of steel on a black-covered table in front of a black
background. When I projected the flying image on it, it
gave me a shimmering silvery quality. The tin gave the im-
age a translucent quality, an airy feeling that the wall pro-
jection didn't have, and I liked that. I angled my camera,
too, and so the image was manipulated three ways: I used a
tilted projector, a tilted surface to receive the projection,
and a tilted camera. Part of the projected image spilled off
the tin, falling into black space and disappearing.

This was a double exposure, but unlike any other
already described. Take I was a photograph of the projec-
tion on the ferrotype tin, filling up only half the frame, the
left side. Take II was identical to take I, placed next to it in
the other half of the frame, slightly lower, with a slight
overlap in the center of the frame.

There is a shadowy area in our work, determined by
each photographer individually, where reality leaves off
and becomes something else, something implied. I hope I
am conveying to you the excitement one gets out of this
work, finding this, getting that, putting bits and pieces to-
gether, and making a new living thing, a new image; and I
hope I am conveying all the satisfaction you can have even
before you get your results.

9

Sandwiches and Montages

FILE SYSTEM

A good file system for your slides is very important in this work. It should be organized so that you know what you have and where it is. Of course, if you get excited or inspired and want to see something, or if someone calls you and says he needs a slide that could be used for such and such, and that he will pay X number of dollars for it, and you start looking, that beautiful file system can get out of order very quickly. But then all you have to do is to sit down quietly and patiently and put the slides back in order.

When my slides come back from the processors I go over them carefully, studying them to see if I got what I wanted. Sometimes you discover that you got something better than or different from what you expected. I feel that studying the slides is a very important phase in the work process. After thoroughly reviewing all the slides in the take, I edit them. If the slides are for a job, I deliver the ones I think are best. Then I divide the rest up into best, second best, and terrible. I very seldom throw anything away unless I have too many duplications. Even if you never use a slide, it can be helpful to have it in the file system where you can easily get at it and see it, even long after you've taken it, at a time when you may have something totally different in your head. It can start a whole new chain of ideas.

I have a consecutive-number-and-category file system. I give each shooting its proper number, which I mark

on a calendar. Along with the number, I write a short description of the shooting. Then I have about ten different groupings—for example, female heads, male heads, scenes, abstractions, mystery. Some people put down the job or project number and the group designation (generally a letter on each slide). I keep some slides on showcards, organized according to subject matter. I keep some slides in trays ready for projection, and I keep the rest in the small boxes they come in from the lab, with the boxes numbered and in their respective groups.

This file system is particularly important for finding material and ideas for sandwiches and montages.

SANDWICHES

So far we have worked almost entirely on multiple exposures, where the principle is to get unexposed and underexposed areas in take I, so that there is unused film, or partly used film, for take II; or to put it another way, there must be dark or black space when you organize your take I. In sandwiching, the reverse holds true. We use the term "sandwiching" when two or more transparencies are put together in one mount. Clear or light areas are needed in each transparency, so that the two separate images can be seen through each other; they can interrelate and interweave, thus creating a brand-new image. Any area of the first transparency that is dark will "hold back" that part of the second transparancy that falls over the dark area, and vice versa. You should be conscious of both elements: how the light areas of the two transparencies interact, and also what you lose in the dark areas.

To understand this better, spread out a variety of transparencies on your slide sorter or light box. To start, work with single-take slides, mainly abstractions and heads. This is the time when you will find that your "terrible" transparencies are useful, especially overexposed ones. Don't limit yourself to 35 mm slides. Put 2¼" square or even larger transparencies on the light box. With your slides in front of you, just start putting one on top of another at random. Study them, see how they work. Sometimes two will work if you turn one around or upside down, or if you flop it. See how colors change when one

Figs. 9-1A—C. Above left, slide No. 1. Above, slide No. 2. Left, a sandwich of slides Nos. 1 and 2.

slide is laid on top of the other. See what happens when the dark area of one transparency obliterates part of the image of another. Study the way different colors and shapes change as they weave in and out of each other.

When sandwiching with 35 mm transparencies, you almost always have to have the slides in alignment. It is possible to shift a little bit, but if you shift too much you might end up with a picture area that is too small. You could also turn a slide sideways, but you must realize that this results in a 24 mm-square area (a little less than one than one square inch) for your picture. The larger transparencies, 2¼″ square and more, give you more latitude to work with in sandwiching: You can shift the transparency so that the edges and the frame lines don't have to meet, and if you turn the transparency around sideways you don't cut down on your picture area. It is because of this that the 2¼″ camera was used for three of the seven projects soon to be described.

Sandwiching is also a way of feeding color into color-slide copies of black-and-white photographs, line drawings, lettering, and mounted black-and-white negatives (see Chapter 8). For sandwiching with 35 mm transparencies, you need empty, open, cardboard transparency mounts or metal mounts with or without glass. When you have 2¼″ square transparencies you wish to sandwich, leave them in their acetate sleeves and Scotch-tape the sleeves together so that the tape does not cover the picture area of the sandwich.

Handling 35 mm materials

When you have found 35 mm slides you wish to put together, you have to remove the transparencies from their mounts first. I suggest that you practice on a couple of slides you are sure you will have no use for (another reason to keep "terrible" slides). With a single-edge razor blade, make cuts (not too deep) diagonally from the four inside corners of the cardboard mount to the outside corners of the mount. Then slip the blade carefully under the inside edges of the mount, being sure not to pierce or cut the transparency. Dotted lines in the illustration (Fig. 9-2) show where you gently bend up the cardboard mounts away from the transparency. You pry these edges up, and then grasp the bent-up edge with your fingers or with a pair of tweezers. Once you get one side off, it is fairly easy to get the other three sides off, and the transparency will easily come out. Be careful, and avoid getting finger marks on the transparency. A pair of stamp-collector's tweezers is useful. Have a clean piece of paper on the table for the transparencies to fall on. Get an empty mount ready and carefully position the two transparencies and lay them on the open mount. (There are mounts which are closed and require pushing the transparencies into position; I don't care for those.) Then close the mount and seal it. The kind of mounts I use have a dry adhesive on the inside; this adhesive melts and seals when heat is applied. Tacking irons available in camera stores for this purpose, but I use an ordinary household iron. Once you have made some experi-

Fig. 9-2. To remove a transparency from the mount, carefully cut along the dotted lines shown in this drawing. Then gently lift the sides of the mount and remove the transparency.

mental sandwiches from existing slides, I suggest that you project them and see how they look blown up.

I explained earlier that transparencies larger than 35 mm were better for sandwiching than 35 mm slides; so whenever a 35 mm camera was used in the ensuing projects instead of a larger one, I will give the reasons for it.

Flying Dancer and Flames

I had a photograph that I took a few years earlier of a dancer leaping, with a scarf trailing behind him like a bird's wing (Fig. 9-3A). I had made a "stretched" black-and-white print of it (Fig. 9-3B). By "stretching" I mean that, when projecting the negative of the print in the enlarger, I tilted the easel so that the dancer's body was elongated and he appeared to be soaring up in midair. The scarf behind him turned into a winglike shape. (This technique is related to the one explained in Chapter 8.) The dancer was in a spotlight, and the background was dark. I made a black-and-white copy negative of the "stretched" black-and-white print, and so the winged dancer became a black silhouette on a clear background. I used a 35 mm camera here instead of the 2¼" camera because I knew I would be using an overall abstract slide, and so no shifting of the two transparencies would be necessary. I then sandwiched this black-and-white negative with a flamelike abstract slide of an out-of-focus piece of crumpled red foil paper and yellow highlights (from a scrim on the light when I made the slide). Only a sandwich could give me a

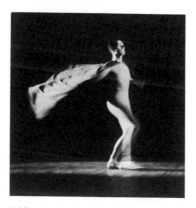

Fig. 9-3A. The original photograph of a dancer wearing a white scarf.

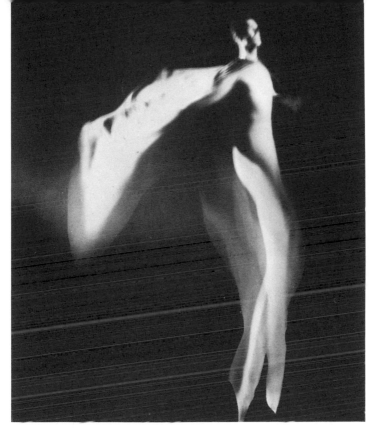

Fig. 9-3B. Tilting the enlarger easel produced this "streched" version of the print. A copy negative was made, and it was sandwiched with an out-of-focus piece of crumpled red foil to produce a black, silhouetted dancer surrounded by flames.

black silhouetted dancer surrounded by "flames." If I had photographed the black-and-white print in color I would have had, like the print, a white dancer on a dark background. With that I would have had two possibilities: first, a sandwich that would show "flames" inside the shape of the dancer on a black background; second, a double exposure that would have given me a white dancer surrounded by "flames." Another thing could have been done with the black-and-white negative of the black dancer on a clear background: I could have made a reverse negative (called a "film positive") and then made a print of that, getting a black dancer on a white background, which, when copied with color film and double-exposed with the "flames,"

117

Fig. 9-4. A sandwich of a
girl and a silhouetted
couple.

would have resulted in having the "flames" inside the
shape of the dancer on a white background.

One shot was a closeup of a girl's face; the other
showed, in full length, a semisilhouetted couple facing
each other. Although they were almost embracing, there
was space between their bodies, as this would have been
confusing in a silhouette. I took the girl's head in the first
shot, very high key, with the left side lighter, and looking
up toward the left. I put a piece of glass patterned with
very fine vertical lines in front of her to soften the face just
enough to keep it from being overly sharp and realistic. I
didn't shoot the couple until the transparencies of the girl
were returned from the color lab. I cut out one of the
frames and laid it on the viewfinder as a guide while pho-
tographing the couple. Because this transparency was to
be used in a sandwich, I photographed the couple on a
white background. I composed the shot so that, when it
was laid on top of the picture of the girl's face, the couple
would be on the left side of the face. I shot it sharp, and to
create an elongated effect I also shot it ouf-of-focus. I was
careful to make sure that the tops of the heads reached the
top of the girl's head, and that their fieet were near the bot-
tom of her chin. I repeat, while shooting the couple, I was
looking through the viewfinder with a transparency of the
girl's face lying on it. It was so well planned that, when the

118

results of the take of the couple were sandwiched with the girl's large head, she appeared to be looking at them. Neither transparency oblitered the other; instead, they enhanced each other (Fig. 9-4). When shooting for sandwiching, it is important that the sizes of the important areas, the tonal balances, and the placement in the composition be coordinated and planned.

Closeups and Scenics

Now I come to a project where an art director for a large paperback book company, Barbara Bertoli, and I had to create seven related covers for a series of books. Each of the seven books was about the same person, but in each book that person lived in a different epoch and in a different place. The problem we had was to convey to the public that the books were connected, but that each book was different. We needed an underlying theme with variations.

After our first conference, Barbara and I decided to use sandwiching. I returned to see her with a selection of slides from my file, which I chose because I thought they might have some bearing on our problem. The slides were not intended for use, except as a reference and an inspiration. We could have used double exposures, or projections. We decided to use a sandwich of the same face for each cover, and to place inside the area of that face a picture of a scene, an object, or a work of art symbolic of the seven different places and epochs. We also decided that each cover would have its own dominant color. The type and the format would be the same for each book in the series, and, needless to say, the titles and the copy would change. A 2¼" camera was to be used for this project.

Because of the specifics of this particular problem, I became strongly aware that if you eliminate the contours of the face and reduce the face to a two-dimensional plane the eyes, the eyebrows, the nostrils, and the lips take up, at the most, ⅛ of the overall facial area. This leaves the balance of the undisturbed areas of the forehead, the cheeks, the nose, the part between the upper lip and the nostrils, and the chin onto which you can add design and other pictorial material. You can eliminate the contours of the face only if you allow no shadows and have absolutely flat lighting. A study of paintings, drawings, and photographs

119

where there are no shadows, particularly Chinese and Japanese art, will make this very clear.

After Barbara and I chose the model, I photographed the model's face in closeup many times, from the same direct front angle, with the same flat lighting, changing only the color filters on the lens and the color scrims on the lights. I used a wide exposure bracketing and shot lots and lots of pictures. Since I was not going to double-expose, I did not make an exposure chart. An absolutely black background being necessary, however, I did make sure that there was plenty of room between the model and the background so no light would spill onto it.

When the transparencies of the model's face came back from the lab, I cut one out and put it in the viewfinder as a guide, so that when I choose the material to be sandwiched I could study it through the camera viewfinder to make sure it would fit properly. A good deal of time was spent in research, finding material appropriate for each book.

In photographing this material, camera distances had to be adjusted and close-up lens attachments had to be used. Sometimes two or three possibilities had to be discarded before we got one that fit the face and at the same time conveyed the right message about the era and location pertinent to each particular book. It was a challenging and interesting project, and entailed much hard work.

Profiles: 3 + 3, Plus

Now I come to a project that required a combination of several techniques. It was a virtuoso performance, with a sandwich that was anticipated and planned for ahead of time thrown in as a final fillip. This shooting consisted of a silhouette with edge lighting, triple exposures in tight areas, an abstract for the fourth exposure, and then the sandwich. All this was done with a 35 mm camera because that camera is best for multiple exposing, the dominant technique of this project. During the shooting, very careful diagrams had to be worked out and followed.

To begin with, I had a silhoutted edge-lighted profile, which I shot smaller with each successive take. For take I, and take I only, a white background was used. The model was seated on a chair in a very comfortable posi-

120

Fig. 9-5. Three combined takes of a model's profile as seen through the camera viewfinder.

tion, with the top of her head level with the top of the chair. A black cloth was on the chair, and the cloth was pulled back at least two feet.

The model had to be very comfortable, and her head had to be supported, as the pose had to be held for a long time. My model stayed seated for the three takes, which is unusual. She could have gotten up because the chair stayed in the same place, and the position of the head resting against the back of it was marked. You could never have used a child, or someone who wasn't serious, as a model for this take.

For take I, I edge-lighted her profile, using a red scrim on the light, leaving the rest of her head in deep shadow. When take I was finished, I moved the camera back a little, changed the background paper to black, and put a blue scrim on the light. If the white background paper had been left up, that part of take I that fell outside of take II (i.e., the part that was larger than take II) would have been washed out. The profiles of takes II and III could only be used to the left of the edge-lighted profile of take I. Or, to describe it another way, the profiles of takes II and III had to fall inside the larger and much darker area of

the profile created by take I. For take III, I left the black background up, changed the scrim on the light to yellow, and moved the camera back, to make the head smaller (Fig. 9-5).

EXPOSURE CHART FOR EDGE-LIGHTED PROFILE

(Light Reading for all three takes: f/5.6 at 1/30 sec.)

Frame #	Take I		Take II	Take III
1	f/4	1/30 sec.	same	same
2	f/4–5.6	"	"	"
3	f/5.6	"	"	"
4	f/5.6	"	"	"
5	f/5.6–8	"	"	"
6	f/8	"	"	"
7	f/8	"	"	"
8	f/5.6–8	"	"	"
9	f/5.6	"	"	"
10	f/5.6	"	"	"
11	f/4–5.6	"	"	"
12	f/4	"	"	"
13	f/4	"	"	"
14	f/4–5.6	"	"	"
15	f/5.6	"	"	"
16	f/5.6	"	"	"
17	f/5.6–8	"	"	"
18	f/8	"	"	"
19	f/8	"	"	"
20	f/5.6–8	"	"	"
21	f/5.6	"	"	"
22	f/5.6	"	"	"
23	f/4–5.6	"	"	"
24	f/4	"	"	"
25	f/4	"	"	"
26	f/4–5.6	"	"	"
27	f/5.6	"	"	"
28	f/5.6	"	"	"
29	f/5.6–8	"	"	"
30	f/8	"	"	"
31	f/8	"	"	"
32	f/5.6–8	"	"	"
33	f/5.6	"	"	"
34	f/5.6	"	"	"
35	f/4–5.6	"	"	"
36	f/4	"	"	"

The only exposure reading that concerned me was the edge-lighted profile, $f/5.6$ at 1/30 sec. (The reading on the shadow side of the face was three stops less.) The bracketing of the exposures was only one stop on each side of the reading and the half-stops between. Unlike other shootings, the bracketing was the same on each frame for each take, since the lighting and the pose were identical. Even though the color scrims were changed, I made adjustments of the lighting distance to make the exposure meter readings the same for the three takes.

For take IV, an abstract, the exposure chart was not used, and the take was bracketed independently of the chart. I had felt I wanted some kind of abstract design on the overall composition. I went out into the street at night and, at speeds of ¼ sec., ½ sec., and 1 second, with lens openings of $f/11$ and $f/10$, I photographed street lights, traffic lights, and moving car headlights. I purposely moved the camera during exposures. I only exposed on every other frame. I was not too sure of this fourth take, and I was not going to take the chance of spoiling the hard work of the first three takes.

Fortunately, the fourth take worked well and gave the impression of the kind of nervous, quivering lines one sees on an electrocardiogram. These lines were relevant to the picture, as it was to be used for an article on psychiatry.

I also did some out-of-focus blobby abstracts, which could have symbolized disturbing, unclear thoughts in the woman's head. I was really excited about this project and could hardly wait until I got the film back from the color-processing lab.

I edited the slides, putting the ones with the best exposures in a separate pile, and then sorted these into three separate groups. I put the ones with no abstracts in one pile, the blobby abstracts in another pile, and those with the nervous lines in a third pile. These last were my favorites. I took a pair that matched from each group, i.e., those with identical exposures. I removed them from their mounts and flopped one transparency of each pair, which gave me a sandwiched slide of six profiles: three profiles facing three, like a mirror image (Fig. 9-6).

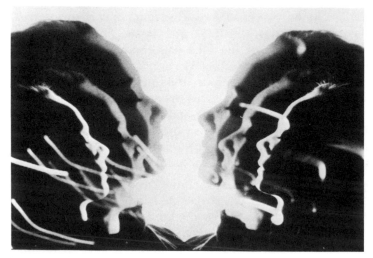

Fig. 9-6. A black-and-white conversion of the final shot—six profiles with streaks of light in a mysterious and moody composition. The color version of this can be seen in the color section.

SANDWICHES AND A
BLACK-AND-WHITE MONTAGE

Photography, like politics, human relations, clothing styles, and the arts, goes through phases when certain things are in vogue and certain other things aren't. Very often what's "in" or "out" isn't openly stated; it's just in the air. And if you don't adhere to these unspoken "do's" and "don't," you are considered stupid or less than human.

Not too long ago, in photography it was considered "bad taste" if you did soft-focus salon-type scenery, or tinted pictures, or montages. There was a time when the professionals made fun of snapshot-style photography and bent backwards to avoid doing a so-called snapshot, even in situations that called for such a picture. Ironically, now there's a movement on pushing snapshot photography as something great. Another "forbidden" was to do a portrait with the sitter posed and aware of being photographed. It was declared that the only good portraits were the candid ones, as if the photographer were a ghost that the sitter didn't know was there.

I always liked everying that carried a message I wished to convey, that expressed something I felt inside, or that reflected something meaningful in its own way. Things are getting better, and one of the thing I like about life today is that everything is becoming accepted for what it is. We are beginning to see all expressions as parts of the whole: short skirts, long skirts, and no skirts; abstract art and representational art; jazz music and classical music; beards and no beards; and curly hair, long straight hair, and short hair. I say, it is not the form that counts, it is the content and the intent. The form is important only insofar as it reveals, to the best advantage, the content and the intent.

Crowd: Solution No. 1

Several years ago, when it wasn't the thing to do, I decided that the essence of something I had to express could best be done with a montage. I had to create, photographically, a crowd of people. I went through my black-and-white negative file for all kinds of faces, young and old, male and female. The one thing they had to have in common was to be facing front and looking directly out. I printed about 30 of these heads, all two inches long. It was a lot of work, but fun. I then cut the heads out from the backgrounds and pasted them down on a board, starting at the top, so that the top of each head would cover the cut just below the shoulder line of the head above it. What I had was a montage of many faces, obviously put together. I had made this montage for myself; but later I got an assignment to produce a color slide of a heterogeneous crowd, a crowd to symbolize all peoples.

I decided to attempt three solutions. The first was to rephotograph this black-and-white montage on color film with a 35 mm camera. As with the sandwich of the dancer described earlier, the 35 mm camera was used because I was going to use an overall abstract for the sandwich and no shifting would be necessary. I also planned to double-expose.

I put a flesh-toned filter on the lens, varied my exposures, and varied the focus from sharp to soft. I double-exposed half the roll with a very out-of-focus abstract of muted colors. All I wanted were imperceptible blobs of

125

color to fill in the shadow areas of the many faces. I laid out the single-take frames on the slide sorter with an assortment of abstract slides. I had already built up a large file of abstractions. I finally made three sandwiched slides of the montage with three different types of abstracts.

Crowd: Solution No. 2

The second solution was a different kind of sandwich. For this one I decided to emphasize the unrelenting movement of a crowd. One evening, along with five friends, I searched until I found a low, brightly lighted store window throwing plenty of light onto the sidewalk. I needed a bright enough background to enable me to shoot at speeds fast enough to prevent blurring of the moving legs. The composition I planned was to include only the legs of the walking people. My friends kept walking back and forth as I, kneeling on the sidewalk, kept shooting their legs. There had to be enough space between the legs to show a multiplicty of legs, without having the legs overlapping. One couldn't plan this, it was a situation where you had to take plenty of shots. My friends were patient and helpful. They walked back and forth. The street was not too crowded. The only planning possible was to keep my friends from getting too bunched up, or in a straight line like soldiers on parade, where all the legs melt into each other and become a solid mass. Actually, it was only when the slides came back that I decided to make a sandwich. Hard as I had tried while shooting, the legs of five people did not give me that jumbled quality, that extra something I felt was needed to convey the impact of an untold number of unrelated people, close together but moving independently. Although using a 35 mm camera was easier in this kind of shooting, if I had done a retake I definitely would have used the 2¼" camera in order to get more latitude for sandwiching. However, sandwiching is not impossible with 35 mm slides, and it was just a matter of spreading the whole take out on the slide sorter and finding slides where the spaces, the legs, and the movement would fall in the right places. You must patiently lay one slide over the other until you get a combination that works (Fig. 9-7).

Fig. 9-7. A slide sandwich that jumbles several people together to create the illusion of a crowd.

Crowd: Solution No. 3

The art director had asked for something symbolic to catch the essence, the spirit, of a crowd, rather than just another picture of an actual crowd; but I knew from prior experience that although clients will say they want something different, they often end up wanting the obvious or the classic, or just the same old treatment of the tried and true. But that's true of a lot of things, and one shouldn't be discouraged or disheartened. I've always accepted the

challenge to discover a new, an original, and a different way of expressing an idea. And then, there is always the chance that I would stumble on something new and exciting that, if not usable for the immediate problem, could be used later in a different situation.

I was satisfied that I had tried the new and the different, but from experience, as a third solution to the assignment, I decided to do the obvious just to keep myself covered. At 4 P.M. one day in late spring, when it was still light, I went to the Staten Island Ferry terminal. I stood in the broad window over the entrance. From there, there is a box-seat view of the many streets that feed into the plaza in front of the terminal. At about 4:30 P.M. people start pouring down these streets, and droves of them come together and move in a mass into the terminal, right under you as you stand in the window. Ensconced in my super-duper spot, I just kept shooting pictures of this mass of people. Although I did not anticipate a sandwich for this situation, I used a 2¼" camera. As 5 P.M. approached, the crescendo of this mass of people reached a peak, and the crowd became an almost single, massive body of movement.

This was the transparency the art director chose. We made a sandwich, not because we needed a more dense crowd, but mainly because the art director didn't want just a simple photograph of a crowd; and we also wanted to avoid any identification of a single person. In this sandwich, with bodies overlapping the parts of bodies obliterated, the individuals in the crowd were broken up and in a way atomized. The sandwich thus transformed the individual pictures from photographs of a "going-home-from-work" crowd to a more universal, a more symbolic crowd. So, in the end, the solution wasn't so ordinary or run-of-the-mill.

COLOR MONTAGES

Sandwiches and montages are similar, not quite brother and sister, but perhaps cousins. Earlier I described a montage made with black-and-white prints. Now I will describe montages made with color transparencies.

I had to recreate, in a photograph, a sense of the density, the crowdedness, and the kaleidoscopic and tumultuous qualities of the city. I went out and shot many pictures around the city, in the streets and from a rooftop. For some frames I masked the lens with a teardrop-shaped aluminum funnel. As I sat in my studio and spread the whole roll of slides out on the slide sorter, I liked one or two shots; but generally I was dissatisfied.

Thinking of the montage of people's faces, described previously, I got the idea of cutting up these 35 mm color transparencies and making the bits and pieces into a montage by gluing them on clear acetate and reassembling them in a 35 mm format. A 35 mm slide seems small enough, and it would appear to be ridiculous or impossible to cut little pieces out of it; but I thought I would try it with some slides that weren't doing me any good anyway.

Putting The City Together.

For this kind of montage, acetate or a piece of clear film is needed. The clear acetate can be purchased in art stores, or you can get empty acetate sleeves, used to cover uncut strips of 35 mm color transparency film, from a color-processing lab. I cut a piece of clear acetate to the size of a single 35 mm frame and placed it inside an open mount. I then took about six city slides and began to cut them up with a single-edge razor blade, extracting buildings and pieces of buildings. I dipped a toothpick in clear glue and put a dot of glue on a piece of slide and placed it on the clear acetate. I moved the little pieces of slides around. Some of the pieces overlapped. There was little control over the composition, it composed itself haphazardly. The lines of the cut edges gave the whole thing an overall webbed pattern that did not distract from, but contributed to, the effect of a many-layered city. I covered the city montage with one frame of an overall abstract design, and sealed the mount. I put the slide in the projector. You need this kind of a blowup to be able to see a thing like this. I had a great slide. The montage did what I had been unable to accomplish with a single-take photograph. Of the 140 color slides I submitted to the Museum of Contem-

porary Crafts (now the American Craft Museum) for an exhibition of photography called "Photo Media," this slide and another montage, next to be described, were among the 12 slides of mine chosen to be shown in the exhibition. The work described in this book covers the gamut from the extremely precise to the accidental. In making these montages, you are working with tiny pieces; so you cannot plan carefully. You must have an overall concept of what you want, and then let it work itself out.

Mixing and Matching

For the second montage that was in the "Photo Media" show, I took a group of slides of agitated faces reflected in polystyrene, a close-up slide of a face with large, staring, transfixed eyes, and a slide of a cat in a crouched position. I glued pieces of these three slides onto a slide of a work of art; the slide's colors had gone sour. I pushed the little pieces around, again not concerning myself with overlapping, just making sure that the part I considered important would show. I could not control the slant of the small pieces of film, and they went off at different angles. The slide was effective, as it helped express an emotional disjointedness, a disturbed human condition.

10

Odds and Ends

LIGHTING

No matter what kind of a studio or working space you have, I presume that you have lighting equipment you are used to and like working with, and that you are the best judge of what equipment is best suited to what you do and the place in which you do it. My concern in this book about the way you work with the lighting equipment.

You can get as good results from the most inexpensive lighting setup as you can with the most expensive. I happen to like the simple clamp socket with the 8″, 10″, and 12″ screw-on reflectors. These weigh very little, are easy to handle, and can be stored in a minimum amount of space. They take up to a 500-watt bulb. I also use quartz lights, which are well balanced for photographing with color.

The type of lighting you use influences what you produce. The types of artificial lighting available during different periods in history, and the natural lighting in different geographical places, greatly influenced the work of painters. The candlelight of Rembrandt's time gave his work a soft warm glow, a subtle color and light quality that we hardly know. The bright, open light of southern France certainly influenced Van Gogh's landscapes and Picasso's later work. The tone and color in the work of a contemporary painter, Alice Neel, changed drastically when she moved from one apartment to another.

If you study the lighting in the theater—at plays, opera, ballet, or the movies—you can get many ideas. The

131

lighting in an old building is totally different from the lighting in a modern structure. Many things influence interior lighting: the fixtures, the proportions of the rooms, the color of the walls, the size of the windows, the height of the ceilings, and so on. Outside, there are innumerable influences on lighting, the most important of which are the time of the day and the season of the year. Of course, you can't discount the geography—the amount of foliage, the openness, the proximity to bodies of water, the distance from the equator, the weather. One can go on and on. All I want to bring to your attention is that since we exist in light, we sometimes take it for granted; you should stop and observe light, and work with it.

Don't be afraid to shoot in all kinds of lighting situations. I feel that instructions that tell you to not shoot in such and such light, or at such and such a time of the day or night, are detrimental. They close the mind, and many things are lost because of that. You're not stupid. Use your judgment. If you want to try something, go ahead and try it. It's not so terrible to make a mistake, and you might come up with something wonderful.

Once you have opened yourself up to light, once you see it and feel what it is, it almost becomes an animate thing. You start working with it, handling it, molding it, directing it, editing it. You start creating mechanical devices to enable you to do this. You can make hoods, cones, funnels, baffles, and masks to hang on reflector floods or spotlights. Or think in reverse. Think of light from the other end, the lens, the door through which you let the light enter that magic black chamber inside the camera where the light does its thing with the film. You can hang your lighting devices—funnels, masks, and the like—on the lens, to direct, edit, and mold the light just before it goes inside.

The clamps of my "cheap" lights sometimes slip on the slender lightpoles, causing the light to fall off the place on which I want it to shine; so just as important as any of the other devices are the small rectangular pieces I cut from an old rubber bathmat to fit inside the clamps so they hold the light firmly in place. Soft plastic kitchen sponges do this job, too.

In your working space you can also use lighting from unlikely sources. Look at someone's face as he bends

over the slide viewer in a darkened room and see the way his facial color and expression change as each slide goes through. Make use of that phenomenon.

Another light source with its own special quality is the projector. (This is apart from its use as discussed in Chapter 8.) The light that comes out of a projector is so concentrated it can be used as a hot spot that you can very easily control and direct. (But use it carefully, because if it is beamed too directly into someone's face it can hurt his eyes.) Make slides of different colored gels, insert one of them in the projector, and you have a wonderful colored spotlight. You can also use the projector to get a shaped beam of light by making slides out of black paper with specifically designed holes in the shapes of circles, ovals, slits, squares, and so on. These you can then project onto whatever subject matter you wish.

You can put the projector off to the side, out of the range of the camera, and with abstract slides get splattered shapes and colors on the background. Or use abstract slides to throw color and design on any subject, and combine this light source with regular lighting.

Although I've already covered this topic in Chapter 5, I'd like to remind you again of the variety of usable lighting available outside the studio—street lights, theaters, stores, lobbies, restaurants, automobile headlights, and the like. I could go on forever. Lighting is available all over; go out, see it, capture it, and use it.

DISTORTION DEVICES BETWEEN CAMERA AND SUBJECT

There are many devices for use in between the camera and the subject; you'll find you improvise when you are confronted with a specific problem and you have to come up with a solution right then and there. (Of course, these are other than the standard devices we've already discussed, such as the star filter and color filters.) You can use these devices any place from right in front of the lens up to the subject or object you are photographing. In Chapter 3, some of these devices were mentioned for use in creating abstractions. Here we'll concentrate on their use with other subject matter.

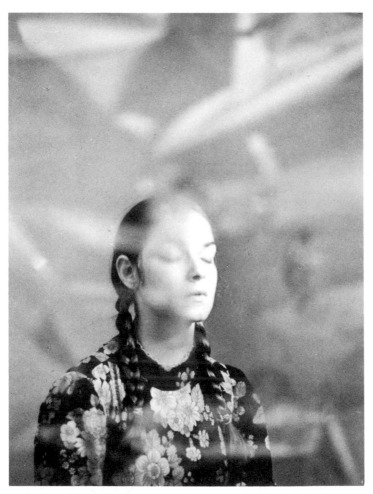

Fig. 10-1. This photograph was taken through a sheet of plain acetate with pieces of colored cellophane glued on it. One light was placed on the model. A second light was placed on the acetate sheet to make sure it would show up. The camera was focused on the model, and a wide lens aperture used for shallow depth of field.

Using Acetate and Cellophane

One device I made was an 28 x 36 cm (11″ × 14″) piece of clear acetate with small pieces of colored cellophane scattered on it. I have also used colored clear acetate with the cellophane. These handy devices slightly

soften the image; and the pieces of cellophane, out of focus in varying degrees, add an indefinable quality to your picture. In addition, you can move the sheet and control where the blobs of color fall.

"Gems" on Glass

I've also taken a large piece of glass, put sequins and brightly colored glass gems on it, and attached it to a chair (Fig. 10-2). This is good when shooting large objects or full-length figures. A piece of glass used this way, with or without embellishments on it, will allow the model to be seen through it, and also reflect what is on the side opposite the model. This is similar to the effect with store windows, when you see through to the display at the same time you see the reflection of the people looking in the window (Fig. 10-3).

You can deliberately place a light (or lights) so that it will be reflected on the glass, and you will get a blob of light or a partial obliteration of the subject, which might be useful for your picture. To do this, start off with a light on your side of the glass, study the subject on the other side of the glass through the camera, and shift the light until it is

Fig. 10-2. The setup for the shot through glass covered with colored sequins. The model and the glass must both be lighted in order to show up in the final picture.

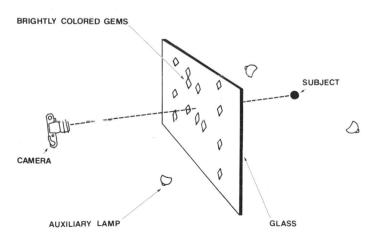

BRIGHTLY COLORED GEMS

SUBJECT

CAMERA

AUXILIARY LAMP

GLASS

Fig. 10-3. This is one type of shot that can be made with the glass-and-sequins setup.

reflected where you want it. I have used several small lights this way, with different colors of cellophane on them, and gotten blobs of red, blue, green, or yellow floating around a model. When angled a certain way, this glass will reflect parts of your studio that you may wish to include in your picture. In my case it is generally the window and the scene behind me that is reflected. You can also use the glass solely as a reflective surface. There are times, for example, when I have deliberately placed a person in a position where he is reflected in the glass, with ghost-like effect.

Patterned Glass

Pieces of patterned glass, with patterns varying from the subtle to the complicated, can be handy. The pieces should be large enough to cover the model's head and shoulders when placed right in front. They are good with still lifes, too. You can also reflect lights the same way you would with the plain glass; unlike plain glass, however, patterned glass does not reflect images. One general rule for using patterned glass: The closer the glass is to the subject, the less distortion there will be.

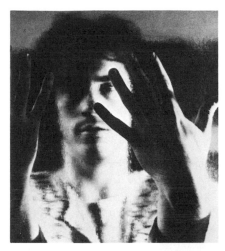

Fig. 10-1A. Lightly pat
terned glass will distort
the model only slightly.

Fig. 10-4B. Here the
glass pattern is much
heavier, causing greater
distortion.

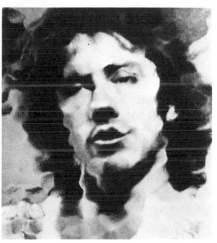

For the sandwich of a girl's head and a couple described in Chapter 9, a piece of patterned glass was used in the closeup of the girl's face. (Fig. 9-4.)

Recently, I did a portrait for a sitter who desired distortion because he needed something attention-getting and offbeat for a brochure and a poster. We used two types of patterned glass, one that had slight vertical lines and another that was heavily mottled, thus giving a lot of distortion. I also had the sitter put his hand in front of the glass for one photograph, so that we would have a contrast between the distorted and the undistorted. (See Fig. 10-4A and 10-4B.)

Cellophane. Sheets of cellophane can be used the same way as the glass. You can get different colored rolls in gift-wrapping shops. You might hang several different colors in long lengths, as the come off the roll or with different degrees of crumpling, between yourself and the model.

Plastic Sheeting. I've also used clear plastic sheeting. One particularly successful use occurred when I splattered red paint on it, let the paint drip down a little, then laid it flat and let it dry. The sheet was then hung from the horizontal bar of the lights stand, in front of two very realistic white masks that resembled death masks, and a picture was taken. I believe red drops of paint would not have been as effective had they been put on the masks directly. However, on the plastic sheet they indicated something macabre.

Multiviewer. I have found objects to use as in-between devices in toy stores and art stores—funny mirrors, plastic lenses, and so on. In an art store I purchased a multiviewer, a series of 25 flat rectangular condensing lenses imprinted on a clear, hard, stiff plastic sheet, 23 x 30 cm (9 " × 12"). I put the multiviewer in front of a man's face. Each lens picked up his face, so the photograph was of many small heads inside a normal-sized head, which showed through the clear section of the plastic sheet (Fig. 10-5). A small plant used with the multiviewer came out as 25 smaller plants.

Magnifier. On exhibit in an art gallery was a flat plastic magnifying lens as part of a large sculpture. A child in the gallery was using the sculpture to play hide-and-seek with a friend, and they were delighted with this magnifying lens. I had my camera with me, and took a picture; in the photograph the child's enlarged head seems very strange because of her tiny hands in front of the magnifying lens.

Plants. A few blades of grass, held in front of the lens, can be a useful device. I have used plastic ferns that way while shooting in the studio. With a black background behind the model, I then did a take II of a large

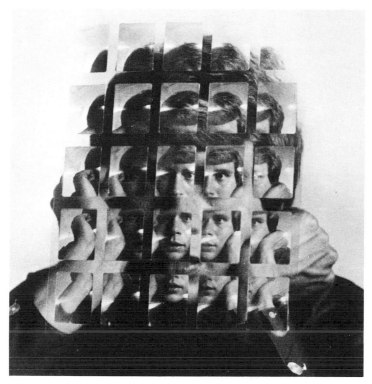

Fig. 10-5. The multiviewer splits the image into many
separate and distinct elements, creating an inter-
esting and unusual effect.

clump of the ferns; I increased the quantity of the ferns by
putting a mirror behind them, including both the real and
the reflected ferns in the take II. In the finished slide, the
model appears to be submerged in a mass of ferns.

Pipe cleaners. A great device I have is a pipe cleaner
made of copper-colored foil. I twist one end around in a
spiral and hold it close to the lens; it throws scattered little
gold glints all over the transparency. Of course, I check be-
fore shooting to see exactly what the pipe cleaner will do
by pressing the depth-of-field previewer button. This is a
precaution you must take with all these devices. They are
great when they enhance or contribute something to a pic-
ture; but remember, if you are not careful they can also
spoil a picture.

WILD SHOOTING

After you've followed the directions carefully and deliberately and have achieved a grasp of the different techniques, and also had the satisfaction of seeing results, give yourself the present of "wild" shooting. Don't mark the film, don't make diagrams. Pick a subject and do all kinds of things with it. As far as I am concerned, you can take as much credit for good accidental results as you can for carefully planned results. I enjoyed doing close-up heads, fully lighted and double-exposed with crowds waiting to get into rock concerts. A friend of mine went out into the street and photographed traffic scenes and buildings during the day with a pink filter. He then put the film through again without taking the precaution of matching the frames and photographed similar things, but with a green filter on the lens. He then put the roll through again at night, deliberately underexposing. Every so often you can see a reddish glow from some of the lights because he used daylight-balanced film with artificial lighting; nevertheless, his results were unique. Although the city is unplanned, disorganized, and congested, in my friend's "wild" transparencies the city emerges with an organized design. There are vertical and horizontal shapes on top of each other. The unmatched frame lines did not distract, and those that showed merged into the overall graphlike design. He had long horizontal prints made, covering approximately 1½ frames, and put them in a show. Because of the contemporary movement to sell photographic prints as art, three of the prints were sold for $100 each.

Shooting "wildly" is opening yourself up to an adventure that welcomes the unexpected. If you have knowledge, experience, and a visual concept, "wild" shooting can be good. "Wild" shooting can also produce an unattractive jumble; but that's the gamble you take.

LATITUDES AND LEEWAYS

Well, we've come a long way together, in and out of all kinds of changes, emphases, expansions, abstractions, sandwiches, and reflections. I hope you have had interesting adventures, and have taken many good photographs.

There is a great deal to absorb and comprehend; you will find that there is no end to this work. There are so many things to handle simultaneously: the correct exposures, the correct color balances, and the delicate meshing of all the elements. I'm sure that, besides finding out the extent of what your camera, your lens, and your film can do, you're also discovering that you can get them to do things they're not supposed to do. I call that area the area of latitudes and leeways. With a variety of combinations, you can extend the margins and the so-called limits of your materials and tools, so that the whole becomes greater than the sum of its parts.

Appendix

Metric Conversion Information

When You Know	Multiply by	To Find
inches (in.)	25.4	millimetres (mm)
feet (ft.)	0.3048	metres (m)
miles (mi.)	1.609	kilometres (km)
ounces (oz.)	28.349	grams (g)
pounds (lbs.)	0.453	kilograms (kg)
pounds per square inch (psi.)	0.0703	kilograms per square centimetre (kg/sqcm)
cubic feet (cu. ft.)	0.0283	cubic meters

ASA AND DIN FILM SPEEDS

ASA	DIN	ASA	DIN	ASA	DIN	ASA	DIN
6	9	25	15	100	21	400	27
8	10	32	16	125	22	500	28
10	11	40	17	160	23	640	29
12	12	50	18	200	24	800	30
16	13	64	19	250	25	1000	31
20	14	80	20	320	26	1250	32

Index